MOTION BY DESIGN

MOTION BY DESIGN

SPENCER DRATE, DAVID ROBBINS, JUDITH SALAVETZ

LAURENCE KING PUBLISHING

Published in 2006 by Laurence King Publishing Ltd
e-mail: enquiries@laurenceking.co.uk
www.laurenceking.co.uk

A catalogue record for this book is available from the British Library

ISBN-13: 978 1 85669 471 1
ISBN-10: 1 85669 471 2

Designed by Judith Salavetz
Additional design by Jeremy Miller
DVD by David Robbins with Spencer Drate

Cover Design: Spencer Drate, Jeremy Miller and Judith Salavetz
Cover photography: Rocco Redondo and Why Not Associates
Internal photography: Jeremy Miller and Eric Heimbold

Printed in China

CONTENTS

FOREWORD

'Kyle, the world needs more graphic designers than film-makers.' When I heard this, I imagined that Alvin Eisenmann was charitably trying to discourage me from pursuing a career in film. I had, for a while, been trying to get Alvin, who at that time was head of the graduate graphic design programme at the Yale University School of Art, to discuss issues about sequence. I believed that main title design was the perfect intersection of my graphic design training and directorial aspirations. It seemed to be the back door through which a graphic designer could become a film-maker. Almost 20 years later I feel Alvin's advice was not what I initially interpreted it as – subjective discouragement – but rather, acute foresight.

Three revolutions have taken place since Alvin made his observation. Shortly after our conversation he walked into our graduate design studio and announced that our class would be the first ever to get Macintosh computers. We would no longer have to use antiquated equipment to set our type. With this new tool we could lay out pages, résumés, magazine spreads and entire books. We were getting in on the ground floor of what Alvin called the 'desktop publishing revolution'. The world needed more graphic designers, and now, with the help of this little box, anyone could be one. By the next morning all 18 desks were ready for production. I missed the smell of the linotronic machine's output and the texture of the ink on the Vandercook press, but the new machine certainly made typesetting easier. It stood to reason that poster-making should be just as easy, but a funny thing happened. Rather than cutting up Xerox copies, taking photographs or actually drawing, as was usually the case, the entire class made posters in Adobe Illustrator, and all of the posters looked exactly the same. Geometrically rendered flat, colourful shapes permeated the hallowed halls. The form was dictated by the machine, and so, surprisingly, was some of the content. Overnight the class had become fixated with this new technological language. They momentarily lost sight of their own creative process, and some even forgot the reasons why they had become artists and image-makers in the first place. (Sadly, to this day many have never looked back.) The loss was a small price to pay for the democrat-ization of publishing and the ability to make professional-looking graphic presentations. Soon no graphic design curriculum would exist without computers.

The second revolution occurred roughly ten years later. The desktop publishing revolution gave way to the desktop film-making revolution. Anyone who could make books could now make films and animation. On any given day we could be authors or film directors, depending on the software. Soon no graphic design curriculum would be complete without the study of motion graphics. The only thing that topped all of this was the third revolution: the World Wide Web, the distribution revolution. With the Internet everyone could now send their creative products all over the world. Everyone's work would be considered, and everyone's opinion could be heard. The race was on, not necessarily to do something that people needed to see but, more pressingly, to do something no one had seen before.

While technology continually makes progress, the same cannot necessarily be said for literature, art, religion, culture or creativity. The amazing things we can do technically make it difficult to resist a modernist arrogance, which suggests that design and culture are also progressing. There is a misconception that graphic design is the mastery of graphic design software. So much of what is called 'motion design' is pushing towards lower-end visual effects and cartooning, leaving behind the content, composition, typography and colour choices that make up the foundation of good design. Not unlike the geometric Illustrator posters my classmates made back then, legions of colourful, silhouetted bodies continuously break-dancing are seen everywhere, as motion designers discover the refined capabilities of programmes that do expediently what is in essence the traditional animation technique of rotoscoping with added robust filters.

Technological innovation continues to be valued in and of itself, but while, thankfully, technology allows certain modes of production, it does not provide a good story or clear communication; nor is it free of the fundamental values by which we judge what is art. A landscape painter is first attracted to art not because he wants to handle the best brushes but because he wants to capture the light that lies behind the landscape. I do not believe in specialization as it applies to art and design. Everyone is ideally working towards capturing the light and meaning that lie behind the landscape, but from different angles. I am unwilling to

accept, for example, that a typographer cannot tell a story. Motion graphics can be a medium through which typographers become more visually sophisticated and add considerably more arrows to their creative quiver, and mastering your own eyes and your own conceptual skills is a better foundation to secure than mastering any machine. An animator who has perfected After Effects but uses a poorly drawn font is capable of making something that may have a lovely, expressive cadence but remains intrinsically ugly. I do not believe that quality and beauty are ultimately subjective. I believe there are fundamentals of form and communication that transcend time.

Throughout all three revolutions and the ensuing upheaval I have tried very hard not to lose sight of my process and my initial reasons for creating. My creative process has at its core an experience recounted in C.S. Lewis's autobiography *Surprised by Joy,* in which Lewis's brother Warren shows him a small garden of dirt and twigs built on the lid of a biscuit tin: 'As long as I live, my imagination of paradise will retain something of my brother's toy garden.' [1] For Lewis the garden contained 'the intense overwhelming desire for an indefinable luminous something that was just beyond his grasp'. [2] It is not just a feeling but a feeling that points beyond itself, an intimation of a spiritual reality. Warren's creation contained a nameless desire, a mystical glimpse of a world that he had not yet seen. Good stories aspire to do this. William Wordsworth refers to a similar feeling in his autobiographical poem *The Prelude* when he describes 'spots of time' [3]: 'childhood encounters with the power of nature that when recollected in later years yield visionary power and insight'. [4] I appreciate work that successfully captures the viewer in its own sense of time, including work whose primary purpose is to entertain rather than inform. Lewis and Wordsworth did not consider it beneath them to entertain their audience, to engage them emotionally or invoke their childlike sense of wonder. The toy garden was a self-contained universe that, in Lewis's case, drew him into its milieu. The static graphic compositions that most inspire me often feel like a single moment in time or a freeze-frame that draws me in. There are numerous examples of this in Paul Rand's work, where it is as though we've come upon one of his compositions just before all of the elements fall to the ground or blow away with the wind. Each work is formally

beautiful and contains thoughtful compositional interplay involving all of its immutable fragments. Every letter is well drawn, and the position of every seemingly free-floating piece complements the placement of the other elements around it. Graphic design that implies movement always fascinates me, but nonetheless the limitations of the static frame make it considerably more challenging to create a self-contained universe. With sequential images we have more at our disposal to involve an audience and transport it to another world. The medium of film equips the designer with a variable that can make it easier to pull someone into the emotional universe of the main character or present a broader picture of numerous things happening at once. Film's ability to compress and expand time and space is something we take for granted, but it is an accomplishment, rather than a given, to be able to capture a unique experience – to capture the light behind the landscape. We now have more frames to let a story unfold. We now have the ability with sequence to show an entire context and the simultaneity of a particular event. I struggle to do so with attention to every frame, composing each with the formal lessons I have learnt from the history of graphic design.

The world still needs more graphic designers. Alvin Eisenmann understood that a sequence of images cannot hold up unless each individual image is strong in itself. He knew that a story needs to be clear before it unfolds. If one frame is flawed, it diminishes the story. As Paul Rand would say, 'An idea is only as good as its execution.' I wanted to be a director, but I would first learn how to be a graphic designer.

Kyle Cooper
Owner and Managing Creative Director, Prologue Films

INTRODUCTION

DESIGN REDEFINED: WHAT IS MOTION BY DESIGN?

Graphics are the most elemental form of storytelling. This has been obvious ever since we were children looking at storybooks. Tales shown through pictures are the most universal and effective means of conveying a message, though the meanings of those tales are also often embellished by our childhood imaginations. We are taught at a very young age, through Saturday morning cartoons and programmes such as *Sesame Street,* to relate more to visuals in motion, because they are convenient, easy to remember – and instinctual. Today this concept has evolved though a convergence of graphic design and film technology into a whole new form of storytelling, which far transcends the Saturday morning cartoons of the 1960s. This compelling new form of design is being advanced by masters of the art such as Kyle Cooper, Garson Yu, Dan Pappalardo (of Troika) and Hillman Curtis, all of whom have contributed their comments and reflections to this book.

All we need to do now that we're all grown up is to turn on the television. A statue is toppled in a political revolution. One politician is claiming to be a lesser evil than his opponent. It's the last episode of *Friends.* The words we hear behind what we see can only add momentary detail to what our vision of a televised event emblazons on our memories and imaginations. The images will be remembered perhaps for years, while we may later supply our own commentary based on how we subsequently interpret the event. With motion pictures, visuals have predominated ever since D.W. Griffith's *Birth of a Nation* (1915), in which there is no spoken dialogue. (In one modern film, Mel Gibson's controversial *The Passion of the Christ,* from 2004, words are considered so secondary that they are spoken in a dead language, Aramaic, yet the images remain strong.) When we interpret what we see on the screen, we become active users, instead of passive viewers. We are no longer leaning back to watch: we are now leaning forward to participate.

The job of the motion graphics designer's is to involve us, consciously or inadvertently, by degrees. Through the magic of his or her intuition he or she is breaking down the barrier imposed by the medium. The motion graphics artist has set us up by introducing us to the message to follow, whether through opening TV or film titles, Internet motion graphics or commercial advertisements.

ROOTS

History is fluid. Technology is fast-paced. So to choose one year as a starting-point for modern motion graphics is somewhat arbitrary. But let's focus on 1995. At that time the Apple Macintosh computer was fast becoming a design fixture in most commercial art departments. It had changed how projects were designed, from a standard of *atoms*, where tactile 'things' are used in the paste-up/mechanicals process, to *bits*,[1] where these things could be manipulated instantly on a computer, allowing greater precision and whole new vistas of design approaches.

It was only a matter of time before this kind of technology would start to change the very nature of design by adding the possibility of putting it into motion. In 1995 that technology was in place. Macs and PCs had become more powerful and faster in the corporate world, while much of academia was still sitting on the fence about graphic technology. Graphics-oriented software had been designed to take advantage of this speed and economy of production. Some of these applications, developed for desktop film/video editing and motion graphics, made it possible for any computer-savvy designer to put their work into motion.

Also at this time a new software company, Macromedia, introduced Director, a programme designed around the use of layers and cell animation, allowing for the combination of type and user-developed graphics, which could be imported from outside programmes, such as Adobe Illustrator and PhotoShop. Since the early 1990s Illustrator and PhotoShop had allowed designers to re-conceptualize type and therefore nearly to redefine its graphic appearance. By 1995 Abode's After Effects was fully in use in the making of broadcast motion graphics. Also 3D design software programmes such as Adobe Dimensions, Pixar's Typestry and Specular LogoMotion were already widely used in the production of interactive CD-ROMs.

By the mid-1990s the World Wide Web, originally invented in 1989 by Tim Berners-Lee, had been popularized by rudimentary browsers such as Prodigy and Compuserve, and had realized explosive growth with the introduction of the communications standards marketed by Microsoft's Internet Explorer (1995) and America Online (1991). The browser Netscape Communicator would come about in 1997, but its foundations go back to 1994.

But also in 1995 another even more important discovery was made, which arguably is a foundation for motion by design. It was generating world attention, but, far from being a piece of computer technology, it was about as low-tech as can be imagined. Deep in a cave in a cliff in France's Ardeche valley, three pot-holers, led by Jean-Marie Chauvet, had happened upon hundreds of paintings and engravings etched into the rock walls. The Chauvet cave paintings are believed to be the oldest found to date.

Among the horses, lions, bears and mammoths depicted, presumably as the story of a hunt, there were various symbols and designs and human handprints, perhaps stamped onto the walls with the slain animals' blood. The hunt depicted was an important event in motion. The symbols meant something to the men who painted them, perhaps to individualize their tribe. The handprints perhaps singled out the prowess of the individual involved in the hunt and tied him into the event. This story, embellished with symbols and handprints, is a prime example of human involvement with the process – and early interactivity. There was no refined system of words used to communicate 32,000 years ago. Art was the prime communicator, and a motion graphics designer may look at the cave paintings and envision words of description materializing from the crags in the rocks.

The beginning of civilization as we know it has been seen as contemporaneous with the invention of writing as a standard of communication. Since the modernist art movement of the 1920s, and more rapidly from the onset of the Internet age, the role of communication through graphic design has been evolving. Day by day, designers are integrating more meaningful graphics to obviate the use of too many words. The inclusion of meaningful graphics has reduced this information to a common denominator geared towards better, more global comprehension. Motion in and by design

allows the designer to fine-tune that information to be accessed by narrow groups of people with a common interest but from different cultures. But this concept of communication is not all that new — in fact, it may be roughly 32,000 years old.

Five thousand years ago the Egyptians used hieroglyphics, a set of symbols depicting an event, usually someone's life. These symbols suggested motion. In fact, the Greek *hiero* means 'to set in motion', and *glyph* means 'symbolic character or sign'.[2] There it is: motion graphics. What we have with motion graphics is twenty-first-century hieroglyphics.

A PERSISTENCE OF VISION

Fast-forward past Mesopotamian, Egyptian, Greek, Roman, Byzantine, Medieval, Romanesque, Gothic, Renaissance, Baroque, Rococo, Neo-classical, Realist and Impressionist art styles. Images painted on walls, wood and canvas can draw viewers in deeper — perhaps into themselves — where they can form their own impressions. By the mid- to late nineteenth century it must have seemed to viewers that the message of art had gone about as far as it could go, but, as we know, the evolving story of the message and the medium was far from finished.

In 1826 Joseph Nicéphore Niépce, a French scientist, pointed a camera obscura out of his window and left it there in the hope of replicating the scene on a bitumen-coated pewter plate in the camera. The camera obscura, which looks like a man-sized box camera, was not a new device. Leonardo da Vinci had used a pinhole version, and Jan Vermeer, the Flemish Baroque artist, had perfected its use with a glass lens. Eight hours after setting up the camera, Niépce checked for results and found the first recorded photograph. Later he tried more artistic arrangements and achieved consistent results, giving birth to the science of photography.

His partner, Louis-Jacques-Mandé Daguerre, carried on the work after Niépce died in 1833, popularizing the method with the daguerreotype, a copper plate coated with silver iodide treated with mercury. His camera rendered an image after only a 30-minute exposure. This brought photography within the realm of possibility for any artist–scientist willing to try it. They didn't even need to know how to paint – only how to keep the camera still while making the exposure.

The new medium of photography was brought to everyone's attention through the work of practitioners such as Gaspard Félix Tournachon (known as Nadar) and William Henry Fox Talbot, and then commercialized by portraitists such as Mathew Brady in the USA. Photography brought the art of preserved likenesses to everyone, as daguerreotypes replaced the common cut-paper silhouettes that many carried around with them. Unlike painting, no matter how realistic, these pictures were recordings of *real* things and events.

A daguerreotype, however, was inconvenient to look at because the viewer had to turn it a certain way towards the light to see a positive image. This shortcoming was rectified by the technology of sandwiching an exposed silver-coated glass-plate negative onto receptive paper to create a positive-image print. In turn, these negatives could soon be lithographed for mass distribution through books and newspapers.

Although there were early *photo-artistes* in the 1870s, such as Eugène Atget, Julia Margaret Cameron and Henry Peach Robinson, photography was considered by many critics to be nothing more than a recording device. It didn't really matter that many of the 'records' were stunning landscapes, as in the works of Americans Timothy O'Sullivan and Carleton Watkins. Their images made the real-life splendour of the American West visible to those who might never get to travel beyond their own back garden. England's Francis Frith took photos of the ancient ruins of Egypt, presenting them to a world that might never have imagined their scale, and might never otherwise have hoped to visit them. Photographs from the war trenches around the world began appearing in the mass media, and their horrific content was brought home nearly instantaneously. Pictures of world events gave rise to a more informed, widely dispersed public. The Information Age had arrived.

MANUFACTURED MOTION

The history of cinema began in 1873, with a horse. The Governor of California, Leland Stanford, commissioned the American–British photographer Eadweard Muybridge to photograph the stride of Stanford's trotting horse Occident. After various false starts Muybridge set up an apparatus to record the movement over roughly the period of time it took

the horse to complete one stride. The results were significant, as they are the first records of motion over real time. These results also showed that the parts of the sum of a horse's graceful movement consisted of a series of awkward leg positions, bearing out photographer Edward Weston's later statement that 'the camera sees more than the mind knows'.

After a brief time away from the camera in 1874, while he was being tried for the murder of his wife's lover (he was acquitted), Muybridge continued his work by recording other animals and humans in motion. He also devised something he called a Zoopraxiscope, based on an existing gadget called a Zoetrope, which had been around since the 1830s. The Zoetrope used sequential drawn images of an action (like an animation) inside a rotating drum, which projected the animation onto a series of mirrors placed in its core. With the Zoopraxiscope, sequential drawings and then photographic images were put on a round disk, where the action could be projected on a wall as a looped piece of motion. Undoubtedly the individuals to whom Muybridge presented these images thought they were engrossing, but the elaborate means of delivery (the Zoopraxiscope) was available to only a small number of people.

Eight years later, in 1885, a flexible film base was developed, first on paper and then on celluloid, replacing the delicate yet cumbersome rigidity of the glass plates used in still cameras. This invention ushered in yet another one – George Eastman's box camera – which was to democratize photography. The release of the shutter made a distinctive sound when a picture was taken: 'kiddack'. The camera, and Eastman's company, came to be known as 'Kodak'.

IF COWS DIDN'T EAT MUSTARD, WE WOULDN'T GO TO THE CINEMA

At about the time Muybridge was taking his pictures of horses in motion, the French scientist Etienne-Jules Marey developed a chronophotographic ('photographs over time') camera that could take sequential pictures – the basis for the motion picture camera. It had been discovered, again through Muybridge's efforts, that the greater the number of captured segments of an action over a given period, the more fluid the motion appeared to be. The mechanics were in place for motion pictures, but at this time there was no

film fast enough to record the action. The film could be loaded with more light-sensitive silver, perhaps, but it wouldn't be as flexible, and the cost would be prohibitive.

Instead, the medium that supported the silver, the gelatin, had to be developed to activate the effects of the light on the silver. It had been discovered that the chemicals in a mustard plant, when added to the gelatin, would do this. The source of the gelatin was the hooves of cows. When cattle grazed on mustard, a delicacy to the unsuspecting bovines, the chemicals in the plant would seep into their systems, and thus into their hooves. This resulted in the development of a workable higher-speed movie film.

In the 1890s the inventor Thomas Alva Edison and a partner, William K.L. Dickson, perfected the idea of Marey's chronophotographic camera and invented a projector called the Kinetoscope. Edison's Kinetoscope was a commercial success, even though it could accommodate only one viewer at a time. Kinetoscope booths were installed in darkened rooms (such as the 'Black Maria', Edison's own studio in New Jersey).

In France in 1895, the brothers Auguste and Louis Lumière devised a camera, the *cinématographe,* that could take sequential images and project them. Using this forerunner to the projector, they could show their rudimentary home movies to crowds in darkened auditoriums in Paris. The motion picture projector had been devised.

Although the apparatus was in place, there were no real films being developed. Soon, however, motion picture producers such as Georges Méliès were creating entertaining films using stop-action photography. Films such as Jules Verne's *A Trip to the Moon,* produced by Méliès in 1902, and Edwin Stratton Porter's *The Great Train Robbery* (1903 – the first film to use parallel editing, showing two things happening at the same time), began drawing in large numbers of fans and curiosity seekers. D.W. Griffith's controversial *Birth of a Nation* was considered the first 'great' film in cinema history, as well as being the first feature-length commercial success. *Birth of a Nation* was just one of a growing number of films coming out of a little back lot in southern California known as Hollywood. The film industry had ushered in a new and lasting form of mass media. While D.W. Griffith developed the close-up shot and perfected the technique of

parallel editing, in Russia Sergei Eisenstein was using the quick cut in his films (for example, *Battleship Potemkin*, 1915), suggesting a range of emotions over short periods of time (a second or less). The quick cut is used *ad nauseam* today in many films and music videos.

THE ART OF LITHOGRAPHY

While Eadweard Muybridge was showing his friends his fabulous moving images in America, in Paris Henri de Toulouse-Lautrec spent his nights in the Moulin Rouge sketching his interpretations of the dancers and call girls surrounding him. He spent his days at the lithographers, hand-etching his sketches onto stone for colour printing. His illustrations called for descriptive titles in hand-drawn characters, which Toulouse-Lautrec worked into the piece as part of the art. The type had to be placed in such a way as to balance the composition, much along the lines of the illustrated manuscripts of the medieval period. While the manuscripts were developed for only a few people to see; Toulouse-Lautrec's posters were designed for mass distribution to drive more business to the Moulin Rouge.

Toulouse-Lautrec's apparently simple approach, with the easily accessible tools of printing technology, was in fact revolutionary. It brought about four major developments in the design industry:

- a whole new awareness about printing

- a new refinement of art-for-profit for mass distribution, in the form of the poster

- a new approach to marketing a product through advertisements designed for the purpose of influencing the viewer to buy

- a new type of art, where graphics combine with illustration, each contributing to the whole

With these came a need for a new type of commercial artist: the graphic designer. There also arose the need for a new type of entrepreneur: the advertising executive.

1907 – SETTINGS FOR CHANGE

Some major revelations in the arts and sciences were beginning to materialize in 1907 and the decade that preceded it. The first of these, the X-ray, was developed in 1896, thanks to technological advances in photography. By 1907 X-ray technology was commonly used to look inside the human body. This ability to turn a human 'inside out' had its impact on the arts and sciences, on how they regarded the human condition and how man explained the universe.

The first of these revelations involved man's awareness of his inner self. Although Sigmund Freud's practice of the new medical science of psychoanalysis was strongly criticized by some of those working in other traditional medical practices, it was gaining its own band of followers. Freud had written *The Interpretation of Dreams* (1899) and *The Psychopathology of Everyday Life* (1904), and had developed a growing following of fellow practitioners, such as Carl Gustav Jung. Within a few years Jung would break away from Freud and establish his own school of psychoanalysis, specializing in human individualism and creativity.

The second revelation came through a 'thought experiment' conducted by the 28-year-old Albert Einstein, at that time an employee at the Swiss Patent Office. It was an extension of another insight, which Einstein had published in a paper on the theory of relativity in 1905, based on the particle theory of light in space. In Einstein's mind there was still one more ingredient needed to complete the recipe for relativity. This centred on the concept of gravitational pull, which blew the doors off the long-held Newtonian ideas of space in a vacuum. The insight came to Einstein at the end of 1907 and rounded out his Theory of Relativity, which, when finally completed in 1915, provided a definition of time in space. The principles of Non-Euclidian (that is, solid) geometry had provided Einstein with the tools to sum up absolutely everything in the elegant formula $E=mc^2$. Einstein is credited with advising his peers: 'Make everything as simple as possible, but no simpler.'[3] The same advice could be extended to artists.

There was another visionary who used the principles of Non-Euclidian geometry in a newfound execution of his work. In 1907 Pablo Picasso, already on the way to becoming a renowned artist, boldly changed his expected style with the

completion of his masterpiece *Les Demoiselles d'Avignon*, the first Cubist painting. Many observers hated the painting, or at least did not understand why any artist, let alone Picasso, would paint such an assemblage of ugly women. Their poses seem awkward, and they appear to be wearing masks. But the geometric dimensions of the forms drew the viewers in, as if they were seeing two sides of the figures at once on a two-dimensional plane. Here was a new abstraction in a painting, which involved viewers by challenging them. It was not for the faint-of-art, and the Cubist style became first more complex, then simplified into pure design.

Urban architecture was also in the throes of change because of a lantern kicked over by the O'Leary family cow in Chicago in 1871, starting a fire that burned for two days, destroying 18,000 buildings and scores of businesses and leaving about 100,000 people homeless. As the city was a growing centre of business, searching for its own identity to rival New York, some urban planning had to be done quickly. It was difficult to build outwards, so the answer was to build upwards. The skyscraper became a symbol of urban and human strength and ingenuity, and its basic forms were to become iconic in graphic design, helping usher in the modernist movement in art.

Solid geometry, the space–time continuum, individuality and ingenuity: the stage was set for a renaissance in graphic design, even as it related to the motion suggested by it, then finally exercised *through* it, into the new century.

A BEAUTIFUL FRIENDSHIP

It's no accident that the rise of graphic design at the beginning of the twentieth century was contemporaneous with the growing popularity of cinema, the golden age of illustration and a surge in the popularity of periodicals and cheap novels. Design fuelled the sales of periodicals by giving them a unique 'classiness' that drove their editors to hire more and more illustrators. Design also gave films their own identity and modernity, as evidenced by classics such as Robert Wiene's *The Cabinet of Dr Caligari* (1919) and Fritz Lang's *Metropolis* (1927).

With a proliferation of posters, advertisements and new typefaces to augment them, along with advances in printing, came the introduction of designer/artists such as Aubrey Beardsley and Will Bradley. At least in part under the influence of the Bauhaus movement, the Beaux-Arts and Art Nouveau decorative styles evolved into the Art Deco style, which celebrated stylish design. Graphic design seemed to drive the styles of painting at the time, as shown in Cubism and the works of the Futurist Fernand Léger and the Dadaist Marcel Duchamp. It also seemed as though graphic design, if not married to many art styles to come, would at least be engaged to them. To borrow what Rick Blaine says to Louis Renault at the end of *Casablanca*, it was 'the beginning of a beautiful friendship'.

THE ART OF DESIGN

During the early part of the twentieth century it was thought by some artists that art had reached the limits of sterility. In 1917 the Dada movement reacted to this and played on emerging technologies by extending the boundaries of artistic expression. In fact, it could be argued that Dada was as much a theatrical as an art movement. Driven by Marcel Duchamp and other artists such as Francis Picabia, the photographer/experimentalist Man Ray and the collagist Kurt Schwitters, expressions of artistic frustration converged through the use of found objects and words, such as the poetry of Dadaist founder Tristan Tzara, who maintained that 'Dada means nothing' (in fact, the word is French for 'hobby horse'). The Dada movement would prepare the groundwork for Surrealism and Constructivism and for the Modernist and Expressionist movements that were to follow. These movements have come to define what we think of as 'Modern Art'.

Also from this came a new sort of design, where the graphics would provide a statement of their own and characterize the modernist style. The Art Deco and modernist styles seemed to go hand in hand, and this showed in many of the advertising posters of the time. Although the graphic image was an important part of the Art Deco movement of the 1920s and 1930s, the key legacy of Art Deco design was the use of *statement*. Statement gave the design purpose and was often driven by the cultural context: in Europe, Socialism and Communism; in the USA, Depression, then industry (through the Works Progress

Administration, which also assured of its status as an art form); and worldwide, the onset of war.

A FLICKERING LIGHT IN A DARKENED SPACE

Motion pictures had become a commercial success by the 1920s, providing cinema-goers with vicarious thrills as they left their everyday world behind and became involved in the emotional and intellectual aspects of the story on the screen. The films' plots became more compelling as the movies themselves evolved as a cultural form. Both subtly and overtly, mass audiences were influenced by what they saw at the cinema. The addition of sound (1927) and Technicolor (1935) engrossed the viewer even more. Advances in cell animation (an extension of Méliès's 'trick photography' from the turn of the century) by Max Fleischer and Walt Disney elevated the mere cartoon to more sophisticated studies in illustrated motion and graphics, while providing new sorts of icons for the audience through characters such as Betty Boop, Popeye, Snow White and Pinocchio.

During the 1930s and the Depression era films provided a form of light escape, and during the 1940s and the war years they were a source of patriotism in the USA and Great Britain, while serving a propagandist purpose in Germany and Russia. Motion pictures had become a source of inspiration and subtle persuasion, infusing and changing the cultural context. Romantic new icons such as Greta Garbo, Clark Gable, Jimmy Cagney and John Wayne stamped their image on the minds of film-goers.

It could be argued that the symbiotic relationship that had developed between Hollywood and the rest of the world was a necessity. Newsreels shown at cinemas before the main feature films delivered 'real' news from the breadline and the front line, setting up a need for information on current events. This, coupled with the subliminal need for 'must-haves', sold to an increasingly competitive public through the art of advertising, created a 'user' out of the viewer and brought in the Age of the Consumer.

But a new kind of medium – television – literally brought it all home. In the USA a ratings system was developed by the Neilsson Company to gauge the health (and future) of television programmes, and in other countries similar systems were devised. The ratings system, based on

numbers of viewers and market share, created a reciprocal relationship between the popularity of the entertainment and the advertising that supported it. The quality of the programming would soon become less of a factor than its number of viewers, so the programmes were aimed at a cultural lowest common denominator. Within a short time it would be the advertiser who would determine the quality of the programme.

Advertising money was all about the numbers, and 'eye candy' became necessary in the battle for the most dedicated viewers. Regardless of the content or quality of the show, the book needed a cover. And promotional animated design would provide this, like a product logo, branding a show to promote viewer loyalty. This called for a new type of designer, who could think outside the traditional grid and work at the fusion of animation, graphic design and the new, still developing, technology of television.

MOTION GRAPHICS

It would be impossible to discuss the history of motion graphics without considering the contributions made by Saul Bass, whose graphic designs are the very definition of motion graphics as we know and use them today. He is legendary for innovative title sequences for some key film titles discussed below. Bass's television credits include the *Alcoa Premiere* (1961), *Playhouse 90* (1960) and static and animated logos for AT&T.

By the mid-1980s in England, Martin Lambie-Nairn was also creating innovative branding, using 3-D animated graphics, for Channel 4, the BBC and others. In the USA, where broadcast was king, the motion graphic designs of Harry Marks set a standard for network branding. Others set their sights on motion graphics in broadcast – WGBH, the Public Broadcasting System's Boston network design department, headed by Chris Pullman, gave rise to such designers as Gene Mackles.

Once television had created a vehicle for motion graphics, the craft was brought to a new artistic level in film titles. Although animated type within film titles had been in use since the days of Georges Méliès and D.W. Griffith and in the genre films of the 1930s such as *King Kong* (1933), they were generally studio-created early experiments, used primarily as special effects.

Inspired by the modernist movement of the 1930s, Saul Bass's film title graphics were a part of the film's identity and served to involve the viewer in the movie from the first frame of the opening credits:

> My initial thoughts about what a title can do was to set a mood and the prime underlying core of the film's story, to express the story in some metaphorical way. I saw the title as a way of conditioning the audience, so that when the film actually began, viewers would already have an emotional resonance with it.

> Saul Bass, interview, *Film Quarterly* (Autumn 1996)

Bass's credits include nearly sixty films, from Otto Preminger's *Carmen Jones* (1954) to Martin Scorsese's *Casino* (1995). During his career he produced some legendary titles and identities, including *The Man with the Golden Arm* (1955), *Anatomy of a Murder* (1959) and Alfred Hitchcock's *Vertigo* (1958), *North by Northwest* (1959) and *Psycho* (1960) (for which Bass also created storyboards for the famous shower scene). Hitchcock had a profound respect for the importance of graphic design in film which is evident in the creativity of his editing. Strong influences from Bass's work can be seen in the work of many of the designers in this book.

Other designers who turned to motion graphics and were also to become legendary for their work include Pablo Ferro, Maurice Binder and Robert Brownjohn (for their *James Bond* film titles) and the brothers Richard and Robert Greenberg of R/Greenberg Associates. Ferro's motion graphics career

extends from *Dr Strangelove* (1963) to *Good Will Hunting* (1998), along with many pioneering television spots. The Greenberg brothers' distinctive early style can be seen in the film credits for *Alien* (1979) and *Altered States* (1980). Finally, the beautiful calligraphic type styles within film created by the Belgian designer Brody Neuenschwander took motion graphics in another direction. Neuenschwander's signature works are *Prospero's Books* (1991), *The Pillow Book* (1996) and *The Bologna Towers Project* installation (2000), which is featured on the DVD that accompanies this book.

These are some of the innovative pioneers who inspired a new sense of motion by design and influenced those who are making it into an industry. Today's practitioners – Hillman Curtis, Garson Yu, Trollbäck + Company, Kyle Cooper (Prologue Films), Troika Design Group and DIGITAL KITCHEN, along with many others – are working in the now well-established, yet changing, field of motion graphics, and are also featured in *Motion by Design*.

The Internet, mobile phones, PDAs and, soon, interactive television all serve to bring more control of information into the hands of the 'user' (the viewer-turned-participant). This is bound to change the way graphic design and motion work together, creating the new category (again, based on older ones) of information design. The artists described here are helping to make history in the future of design by making information an art in and of itself.

David Robbins
New Media Director, DHR New Media, LLC

OPENING CREDITS

When the subject of motion graphics comes up, there are a few names that leap to mind. We think of Saul Bass's innovative work in the 1960s – *The Man with the Golden Arm, Vertigo* and *North by Northwest* – as well as Stephen Frankfurt's *To Kill A Mockingbird*. In the 1970s and 1980s Richard Greenberg furthered the form, creating memorable title sequences for *Superman, Alien, Altered States, Body Double* and *The Untouchables*. Of course, I will always remember the baby floating in the sky at the beginning of *The World According to Garp*. In the 1990s Kyle Cooper's titles for *Seven* set off a new wave in title design, influencing cinema motion graphics for the decade to come.

Cinema motion graphics, within the context of motion graphics generally, represent a convergence of graphic design, film, video and photographic technology. Television motion graphics tend to have in-your-face visuals and eye-catching layouts. Cinema motion graphics are more about image-making and storytelling. Both design approaches are legitimate, but they serve different purposes. While TV motion graphics are intended for fast reading, cinema motion graphics encourage the contemplation of a story that unfolds slowly.

What makes motion graphics cinematic (apart from the fact that the medium is film) is that when we look at an image in a cinema, we have no other distractions and are willingly led by the film-maker into a fantasy world. Cinema motion graphics help to set the tone of the world into which the film-maker wants to draw the audience. Therefore the most important effect motion graphics can have is to make an emotional connection with the audience. This connection is made by strategically integrating the visual with sound. The audio element is essential. It takes 51 per cent music and audio effects plus 49 per cent picture to create a complete emotional sensation.

The history of film title design has been greatly influenced by changes in technology and culture. From *To Kill a Mockingbird* to *Seven* we can clearly see a dramatic transformation in the style and development of this genre – changes engendered by rapidly advancing digital technology, along with the entity of marketing and consumer pop culture.

When I started my career as a motion graphics designer, the graphic technology was primitive compared with today. We dealt solely with 2D space and elements. We could only achieve effects that could be created with an optical printer and animation stand. Today everything is digital. Design and visual effects have converged. Digital tools have made it possible to create virtually anything we can imagine. That said, it is still about our imagination. Cinema motion graphics are not about a moment of motion graphic expression such as we see on TV; rather, they create a film sequence that informs the audience of the story that is about to unfold.

Garson Yu
yU+co.

Trollbäck + Company
Still, the Children are Here

STUDIO PHILOSOPHY

Trollbäck + Company believe that 'if you want to communicate with people, you have to make them care about what you are saying. This emotional connection is the result of a process where an idea is turned into a concept, and that concept drives the creative execution.' This means that every solution will be unique. Trollbäck say they are 'not interested in repeating a graphic style or trend again and again. The design is born from the idea, not the other way around.'

'Our company consists of individuals with varied backgrounds and forms of expression. In any truly creative environment collaboration is the key, whether it be with animators, architects, artists or writers. Through this collaboration we question old routines, opening doors by seeing things in new and different ways.'

CREATIVE PROCESS

This opening sequence serves as an introduction to a documentary about a rice-growing community in north-eastern India. Showing facts related to the story of rice, one of the most fundamental foodstuffs for mankind, through a journey using different illustration techniques, it ends with simple brushstrokes on a canvas, the design equivalent of a grain of rice.

PRODUCTION PROCESS

Still, the Children are Here was produced from a combination of handmade illustrations, which were scanned, and computer graphics. The flat artworks were divided into layers and animated with the 3D elements. It was combined and composited in After Effects and filmed out from 2k digital files.

TOOLS

After Effects, Illustrator, Photoshop, ink and water

CREDITS

Creative director: **Nathalie de la Gorce**
Designer: **Tesia Jurkiewicz**
Visual effects director: **Chris Haak**
Executive producer: **Julie Shevach**
At Mirabai Films
Director: **Dinaz Stafford**
Producer: **Mira Nair**
Executive producer: **Roger King**
Music: **Nitin Sawhney**
Editor: **KA Chisolm**
Post-production supervisor: **Julia King**
Post-production assistant: **Sowoon Cho**

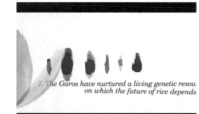

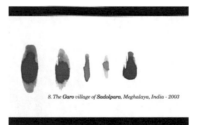

▶

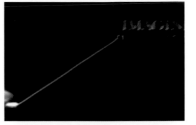

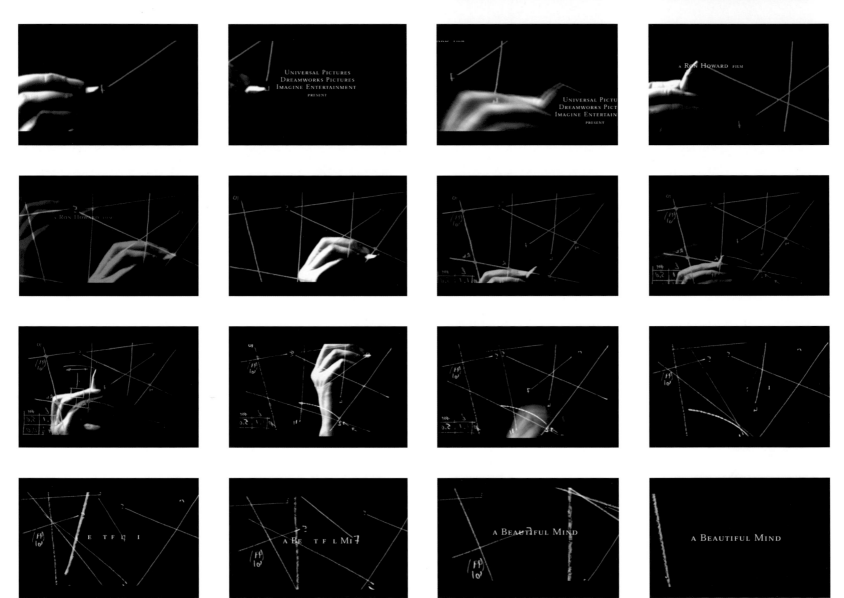

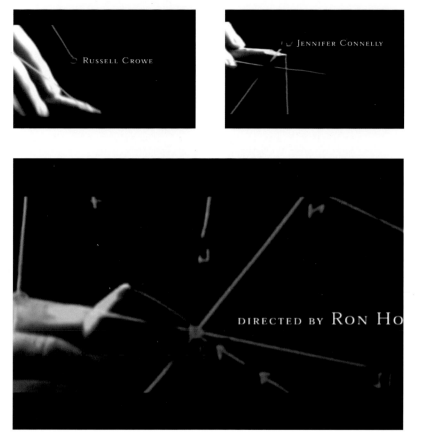

TOOLS

After Effects, Maya, 3D/Effects, Avid, Lightwave 3D

CREDITS

▮▮ Creative directors: **Laurent Fauchere, Jakob Trollbäck**
Design and animation: **Laurent Fauchere, Chris Haa**

CREATIVE PROCESS

The opening sequence for any film seeks to set up a mood, an atmosphere that serves as a bridge from the outside world into the film. Besides setting the tone, it's also a focusing event so that the audience has a moment to adjust. As Trollbäck + Company explain: 'For this to work, the titles have to capture something essential about the movie, but ideally they also need to be clever, interesting and attractive. Often ideas come from an event, or a thought, in the film. It may be a turning-point or a practical or ethical dilemma. It has to be interesting enough for the design team to be able to explore it visually for two minutes, and it also has to feel right for the film.'

Trollbäck explain the dangers: 'You have to make sure that you are on the same wavelength as the director, or you can side-track the whole film. In *A Beautiful Mind* there is a great moment where Nash is formulating his thesis, writing his formulas on the dorm room window. This was both an emotional and a visual event, and it became a perfect vehicle for the opening sequence.'

'The titles for *A Beautiful Mind*, which we consider among our top ten, were ultimately cut out of the opening to gain two minutes, and the credits rolled over the first shot.'

PRODUCTION PROCESS

To achieve the floating equations that come to life in the sequence Trollbäck doodled on a large sheet of glass with a white grease-pencil. 'We shot one another drawing lines and curves and then sifted through the footage in our Avid to find the shots that worked the best within the story of the title sequence.' The camera moves were all digitally created with After Effects and Lightwave 3D, as were the 3D moves of the chalk markings.

Prologue Films ▶

Spider-Man 2

STUDIO PHILOSOPHY

Prologue's hope is for 'the studio to be a community where each designer becomes better at what they do because they are part of that community.' They look for what each member of the team excels at and try to cultivate that area of expertise, giving them responsibility for the part of a project which best utilizes their skill set and allows them to succeed. At the same time, they believe, each skill set is enhanced and broadened by the proximity of others. 'As iron sharpens iron, so we sharpen each other and make each other better at what we already do and what we have yet to do. Ideally, our capabilities and our identity are stronger because of who we are as a group.'

'We seek to do work that engages people emotionally so that others, by looking at our work, can participate in our process. We feel that creating prologues, which in a perfect world actually become the first scene of a feature, is a great context for us to pursue our creative goals. In addition to main titles, we've had rewarding experiences designing special sequences in the body of features.' Prologue believes that any creative opportunity, regardless of its scope or medium – whether it is film, entertainment marketing and branding, video game design, commercials, broadcast design,

interactive branding or environmental experience – has the potential to become something great. It is the studio's approach and attitude to each project that will ultimately determine a design's success.

'As a group, we feel better qualified to initiate technological change and, more importantly, creative innovation. We love the challenge of partnering and helping clients who have put their trust in us to solve difficult, creative problems in the most innovative way possible. We are creating a community that challenges the way we think about design, individually and collectively.'

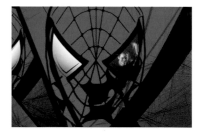

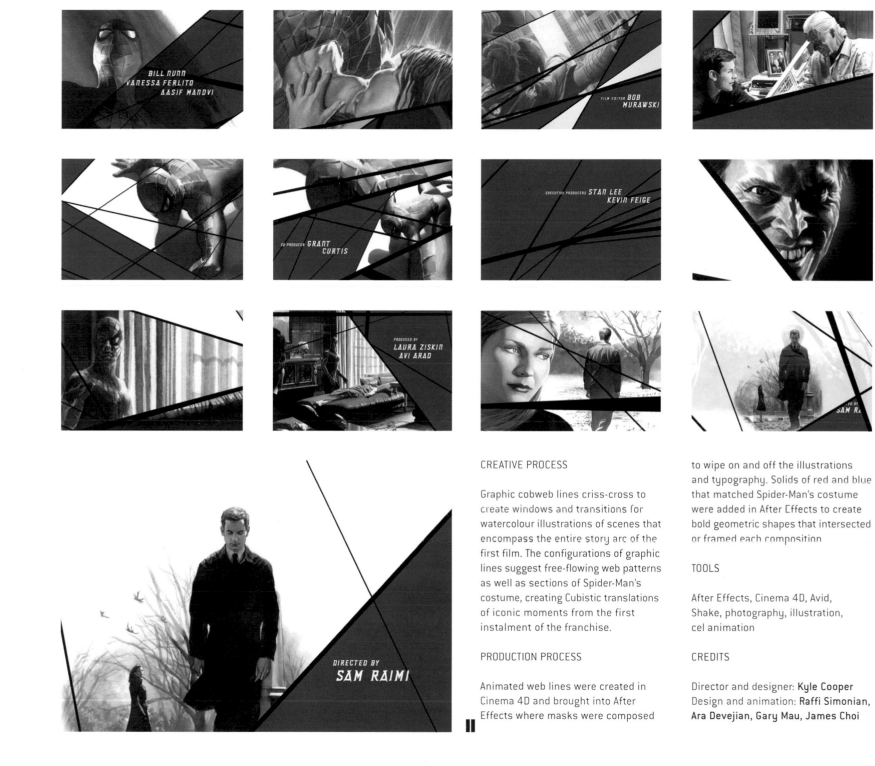

BILL NUNN
VANESSA FERLITO
AASIF MANDVI

FILM EDITOR BOB MURAWSKI

CO-PRODUCER GRANT CURTIS

EXECUTIVE PRODUCERS STAN LEE
KEVIN FEIGE

PRODUCED BY
LAURA ZISKIN
AVI ARAD

DIRECTED BY
SAM RAIMI

CREATIVE PROCESS

Graphic cobweb lines criss-cross to create windows and transitions for watercolour illustrations of scenes that encompass the entire story arc of the first film. The configurations of graphic lines suggest free-flowing web patterns as well as sections of Spider-Man's costume, creating Cubistic translations of iconic moments from the first instalment of the franchise.

PRODUCTION PROCESS

Animated web lines were created in Cinema 4D and brought into After Effects where masks were composed to wipe on and off the illustrations and typography. Solids of red and blue that matched Spider-Man's costume were added in After Effects to create bold geometric shapes that intersected or framed each composition.

TOOLS

After Effects, Cinema 4D, Avid, Shake, photography, illustration, cel animation

CREDITS

Director and designer: **Kyle Cooper**
Design and animation: **Raffi Simonian, Ara Devejian, Gary Mau, James Choi**

Prologue Films

kiss kiss bang bang

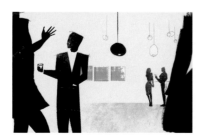

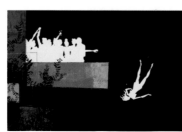

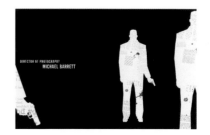

CREATIVE PROCESS

Using crime novels from the 1960s as a central theme, Prologue developed a number of ideas for this opening sequence, ranging from a photographic table-top shoot to graphic solutions that were stylistically similar to titles Saul Bass had done in that era. Certain metaphors, like those pulled from the novels, would direct the story but not give away the plot. At times, the sequence nods to scenes in the film, and other times it plays out abstractly, interweaving representations of the film's characters with parts of urban LA and the Hollywood Hills. 'Fortunately, the music fits the mood of the concept perfectly, so we let it drive the animation and design.'

PRODUCTION PROCESS

Many elements in the sequence were hand-drawn or had a photographic source and were then taken into After Effects for final animation. Some landscape structures were built in 3D, like the fence and freeway overpass which were constructed in Maya.

TOOLS

After Effects, Alias Maya, Shake, photography, illustration, cel animation

CREDITS

Director and editorial: **Danny Yount**
Design and animation: **Danny Yount, Stephen Schuster, James Choi, Evan James, Gary Mau**

Prologue Films
Godzilla: Final Wars

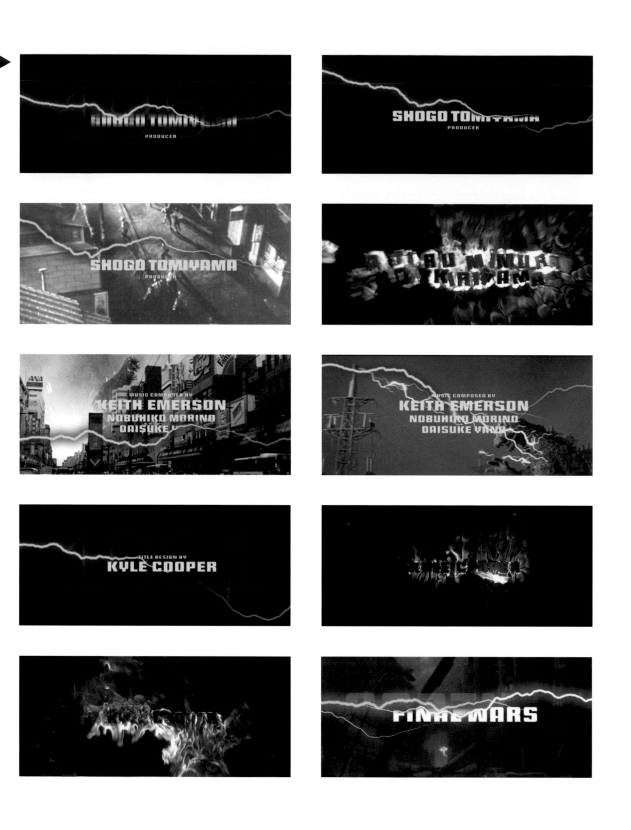

CREATIVE PROCESS

After viewing many hours of existing *Godzilla* footage, the studio confirmed that this oversized reptile likes to smash things; in his wake, buildings break off into flaming pieces and crash to the ground. Prologue replicated this in their typography by cutting letters out of wood, setting them on fire and dropping them from the ceiling. Using these very simple means, the type became the flaming shrapnel from the buildings being destroyed by Godzilla.

PRODUCTION PROCESS

Because of the practical effects used in the animation of the title credits, very little animation was done in After Effects. Instead the entire sequence was put together in Final Cut, then taken back into After Effects to add lightning effects to the title cards and into Shake for final colour correction.

TOOLS

After Effects, Avid, Final Cut Pro, Shake, photography

CREDITS

Director and designer: **Kyle Cooper**
Design and animation: **Graham Hill, Min Roh**
Directors of photography: **Keith Cooper, Daria Polichetti**
Editorial: **Kyle Cooper, Lauren Giordano**

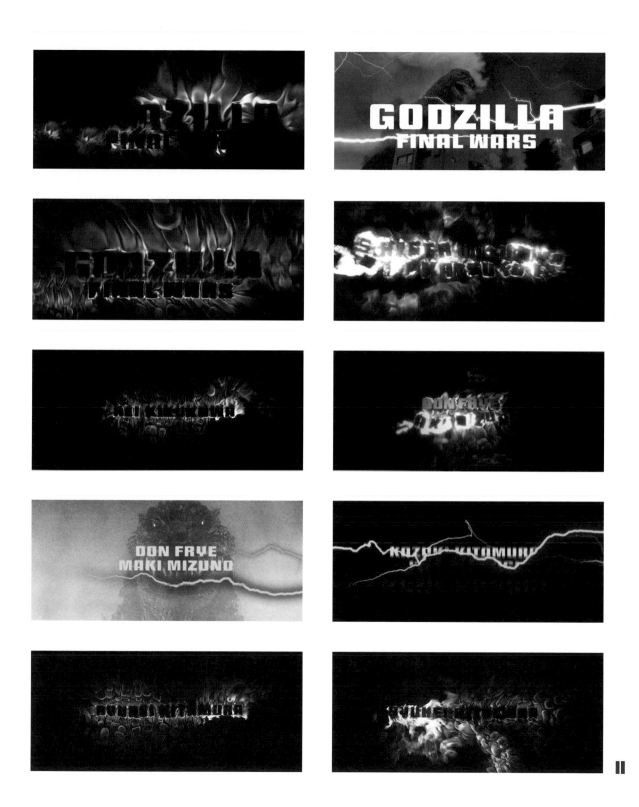

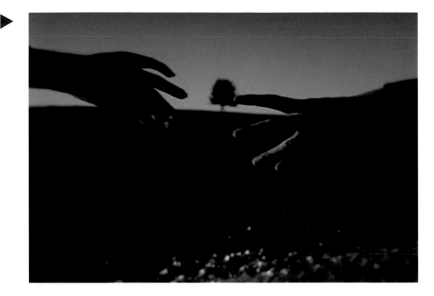

DIGITALKITCHEN
Six Feet Under

LAUREN AMBROSE

GUEST STARRING
RICHARD JENKINS
AS NATHANIEL FISHER

CASTING BY
JUNIE LOWRY JOHNSON C.S.A.
AND
LIBBY GOLDSTEIN

EDITOR
CHRISTOPHER NELSON, A.C.E.

PRODUCTION DESIGNER
MARCIA HINDS-JOHNSON

DIRECTOR OF PHOTOGRAPHY
ALAN CASO, A.S.C.

CO PRODUCER
LORI JO NEMHAUSER

STUDIO PHILOSOPHY

DIGITALKITCHEN was founded by Paul Matthaeus as the digital studio for his independent advertising agency in Seattle. The DIGITALKITCHEN charter has always been to cultivate and advance broader experimentation and creativity in full-motion film and electronic media, leveraged with an agency-based faculty for strategic brand-building.

'In advertising, there's a tendency to "componentize" the different disciplines of production: a different team or firm for design, live action, sound design, music, edit, VFX and finishing', comments Matthaeus. 'The ensuing process compels a linear creative process that seldom advances the creative product. The goal of DK is to direct and manage nearly all the components in parallel, maximizing inspiration and collaboration between all our different disciplines.'

CREATIVE PROCESS

Show creator Alan Ball and executive producer Alan Poul approached DK with some music – no preconceived ideas or stipulations for a showcase of stars. DK explored a number of directions and ultimately took elements from three very dissimilar approaches. Ball's work is distinguished by his ability to touch the banal and the sublime. 'After agreeing on the general aesthetic we went about cementing the shot list that would capture Alan's dichotomy of the literal and metaphorical, culminating with the tree on the hill, rising from the shoulders that have passed before it.'

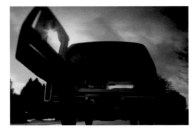

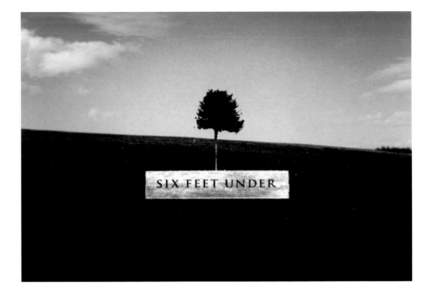

PRODUCTION PROCESS

Largely a live-action initiative, this job required significant scouting and planning to cover all elements of the shooting boards. Because of the silvery light of the America north-west in late winter, the team opted to shoot in and around DK's Seattle office. The wilting flowers and the lone broadleaf tree on a hill proved the most challenging. The signature tree had to be cut from someone's front yard for a fee. The flowers were lilies, selected both for their funeral connotations as well as the speed at which they wilt. DK tested this by leaving dry lilies in a closed room full of cine lights to time their demise. They then configured a motion control rig to dolly through the shot over ten hours.

Many shots had to be manipulated in post production, including the flowers, which had to be digitally painted with a brown patina. Because music was such a strong component in this piece, it was imperative that the unfolding of the edit should feel musical and follow the arc of Thomas Newman's gorgeous score. Final finishing after picture-lock included a custom-built 'patina' over all the footage to contribute to the archival sense of the piece.

TOOLS

Motion Suite, Media Composer, Combustion, DaVinci film transfer, Flame, 16mm motion film, time-lapse motion control

CREDITS

Chief creative officer: **Paul Matthaeus**
Executive producer: **Don McNeill**
Producer: **Lane Jensen**
Lead designer: **Danny Yount**
Designers: **Brian Short, Jay Bryant, Scott Hudziak, Janice Harryman**
Editor: **Eric Anderson**
Composer: **Thomas Newman**
Client: **HBO / Actual Size Films / Greenblatt Janollari**

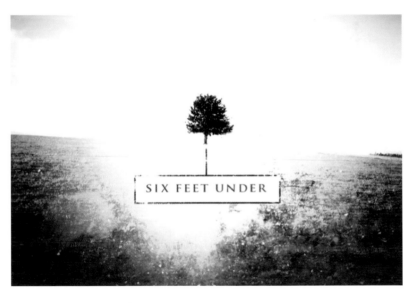

DIGITALKITCHEN
Nip/Tuck

CREATIVE PROCESS

Following in the wake of *Six Feet Under*, DK was again granted an opportunity to abandon the typical turn-and-look formula of conventional serial television. In this case both time and the dollar canvas were smaller, so DK was forced to work in more pragmatic terms. 'The mannequin surfaced as an involving metaphor for the Western obsession with appearance over substance.' Subtle cues to real flesh and blood are provided courtesy of composited facial features and hands which spontaneously come to life.

PRODUCTION PROCESS

Mannequins were shot entirely in the basement of the DK Chicago facility and composited with facial features, still images and time-lapse photography of sky and clouds. At DK music always plays an important role, so edit and design worked in lock step with a licensed track.

TOOLS

Motion Suite, Media Composer, Combustion, DaVinci colour correction, Flame, Hi-definition videography

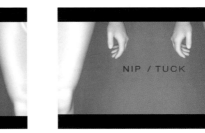

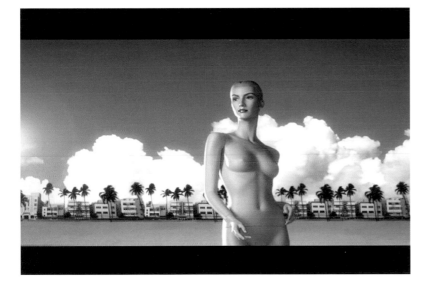

CREDITS

Chief creative officer: **Paul Matthaeus**
Executive producer: **Don McNeill**
Producer: **Mark Bashore**
Creative directors: **Vince Haycock, Paul Schneider**

Lead designer: **Vince Haycock**
Flame/Inferno: **Chris Markos**
Animation: **Vince Haycock, Chris Markos**
Editor: **Eric Anderson**
Director of photography: **Russell Harper**
Client: **FX / Shepherd Robin Co.**

DIGITALKITCHEN
Kingdom Hospital

CREATIVE PROCESS

After a wide range of concepts had been explored, a direction based on the surreal photographic tableaux of fine art photographer Jerry Uelsmann was selected. With a 40-year career that began long before the digital revolution, Uelsmann has been a major force in American photography and was a determining influence on the DK founder's academic pursuits. With Jerry's blessing, DK went about engineering motion into a library consisting strictly of still images.

PRODUCTION PROCESS

Selective animation of the multiple-image tableaux required gathering separate images of Uelsmann's composites and then determining what could be animated and what had to be re-shot to emulate the original. Using particle generation and existing motion content as matte elements meant that surprisingly few images needed to be re-shot in film.

The final resolve to the hospital-tree was inspired by an Uelsmann image but needed to be rebuilt entirely in 3D in order to match parallax and keystoning as the camera pans from earth to sky. 'Ultimately, the success of this project depended on the perfect blending of still images, live action, stock footage, visual effects and 3D/CG – set in perfect time to the

music track. This was a testament to collaboration, communication and co-operation among a diverse team of artists, scattered from literally one corner of the USA to the other.'

TOOLS

Motion Suite, Media Composer, Combustion, DaVinci film transfer, Flame, Retimer, XSI SoftImage, 16mm motion film

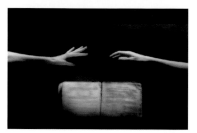

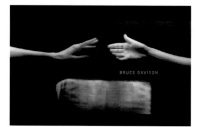

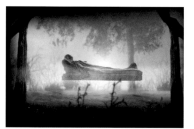

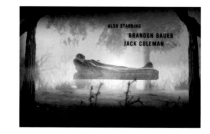

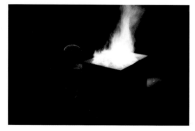

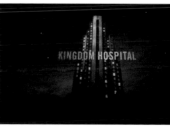

CREDITS

Executive creative director: Paul
Matthaeus
Creative director: Matt Mulder
Designers: Colin Day, Thai Tran
Flame/compositor: Chris Markos
3D design: Dade Orgeron
Executive producer: Wendy McCarty

Producer: Tracy Chandler
Editor: Josh Bodnar
Client: ABC / Sony Entertainment /
Stephen King / Mark Carliner

yU+co.
Taking Lives

STUDIO PHILOSOPHY

The unconventional logic guiding all of yU+co.'s work is that design is not art. As Garson Yu comments: 'We don't indulge our creativity for the sake of art; instead we embrace our creativity for problem-solving ... for communication ... for storytelling. There is always room for creativity within a confined idea. We want to inspire and also to be inspired.'

CREATIVE PROCESS

yU+co. delves into the dark and disturbing world of serial murder in its main title sequence for D.J. Caruso's psychological thriller *Taking Lives*. The tense, expertly crafted sequence, conceived and directed by Garson Yu himself, encapsulates the film's central conflict between an ingenious serial killer and the FBI profiler attempting to capture him. POVs shot from the agent's perspective show him poring over microfiche copies of newspaper stories and police reports of the killer's 15-year murder spree. Alternate scenes offer extremely close views of the killer's facial and body features as he methodically goes about altering his appearance. 'The title sequence aims to fulfil a narrative function and engender a strong emotional response. It tells the audience who the killer is, what he has done and how he operates; it also lets them know that someone

the latter have been overused while the former has a familiar look yet is graphically interesting, and it also conveyed the idea of going back in time.' yU+co.'s design team created scores of newspaper layouts, police reports and crime scene photos, had them transferred to microfiche format, then scanned them so they could be incorporated into the film. Owing to the microfiche's small size, every element had to be very carefully planned. The production team performed numerous tests to ensure that key typographic elements were properly sized.

yU+co. departed from literal reality by injecting more movement into the sequence for dramatic interest. In addition, the studio produced live action elements, including the shots of the killer shaving, applying contact lenses, dyeing his hair and fitting a set of dentures. They also shot the hands of the FBI agent manipulating a battered microfiche reader. For the title credits themselves the designer wanted a font compatible with the microfiche medium, so they chose to produce them with an IBM Selectric typewriter. Even then the type was too clean, so carbon paper was used to produce dirty and degraded type.

TOOLS

Photoshop, Avid, Inferno

CREDITS

Director and creative director: **Garson Yu**
Producer: **Buzz Hays**
Art director: **Yolanda Santosa**
Editor: **Joel Plotch**
Inferno artist: **Danny Mudgett**
Director of photography:
Kramer Morgenthau

is working very hard to catch him. The close-up of the killer using a razor blade to scrape hairs from his neck, on the other hand, is intended to produce a visceral reaction, to make people uneasy about what is to come.'

PRODUCTION PROCESS

Microfiche is a central design element of this piece and is used both to convey narrative information and to reveal the names of the film's cast and crew. 'We chose microfiche rather than newspaper clippings, because

Imagining Argentina

CREATIVE PROCESS

Movie main title sequences often perform a narrative function, providing the audience with information about the film's back-story. The title sequence for *Imagining Argentina* does that, but it also goes beyond simple exposition as it seeks to put viewers in a certain frame of mind. Here the audience is presented with a montage of grim, grainy, black-and-white news footage documenting Argentina's 'Dirty War'. Even those unfamiliar with this history cannot help but be moved and troubled by the violence and pain recorded in these images.

The editorial pacing is thoughtful and deliberate. Images fade in and out of view like frail memories or freeze momentarily like a thought that sticks in the mind. The graphics add subtle reinforcement to the themes of events remembered and forgotten, of lives once here and now gone, as individual characters on the screeen disappear before the rest of the type falls away.

PRODUCTION PROCESS

yU+co. combed through hundreds of hours of news footage and photographs to find the elements for the narrative they wanted to created in the title sequence. The selected footage was heavily processed to create consistency among elements derived from diverse sources. Textures and colour treatments were additionally applied to some images. Inter-cut scenes drawn from the film were also processed, but in a less aggressive way to make those elements blend with the news footage while still remaining distinct. Although all of the images have been heavily edited and manipulated, the technical process is meant to be invisible to viewers, who are left with the sense that they are witnessing 'real' events.

TOOLS

After Effects, Illustrator, Photoshop, Media Composer

CREDITS

Creative director: **Garson Yu**
Typographer: **Yolanda Santosa**
Editor: **Tony Fulgham**

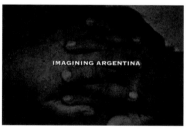

JOHN WOOD CLAIRE BLOOM

argentina producer RAÚL OUTEDA

line producer JOSÉ LUIS ESCOLAR

costume designer SABINA DAIGELER

production designer BÁRBARA PÉREZ SOLERO

music by GEORGE FENTON

editor GEORGE AKERS

co-producers JOSÉ MARÍA CUNILLÉS
ISABEL MULÁ

co-executive producers LUCAS FOSTER
JORDI ROS
LOURDES DÍAZ

executive producers KIRK D'AMICO
PHILIP VON ALVENSLEBEN

produced by GEOFFREY G. LANDS
MICHAEL PEYSER

and directed by CHRISTOPHER HAMPTON

yU+co.
Stealth

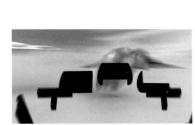

CREATIVE PROCESS

The opening title sequence for this high-tech action movie (above) sets the stage for a story about a futuristic military aircraft run amok. The challenge for yU+co. was to create a title sequence that reflects the slick military precision that characterizes the aircraft, while eliciting the thrills and tension inherent in the story. 'The sequence first has to establish the film's back-story with expository text that flies over an aerial shot soaring above the clouds. A flying object approaches from the distance, which at first appears to be a Stealth fighter. It creates a sense of apprehension as the audience tries to identify it. As it nears the camera, the shape breaks apart and forms the movie's title, in a custom-designed metallic font. Stealth fighters smash through the title, racing towards the camera.'

The actor credits at the end of the film (opposite) use typography over a dynamic, energetic background created from radar read-outs and digital displays from the film's artificial intelligence plane. The slick, contemporary visual elements convey the cutting-edge technology of the plane while also creating a sinister, unsettling tone.

PRODUCTION PROCESS

Inspired by the Stealth fighter, the designers created a font that is streamlined, sleek and wide, with a low profile. Once the font had been designed in 2D, it was rendered in 3D and its movements were animated over the aerial footage. 'For the main titles at the end we needed to create a suitable background environment for the typography to play against. This was done by using CG elements created for the film, and then digitally modifying them to create a unique and uniform look.' Certain elements, such as the wire-frame Stealth fighter, were original artwork created by yU+co. The animators manipulated and enhanced the imagery to create an intense, charged, dynamic feeling. The quick flashes and jarring movements were incorporated to give the viewer a sense of danger and excitement fitting the film's mood.

TOOLS

After Effects, Illustrator, Photoshop, Media Composer, Font Lab 4, Maya, Shake

CREDITS

Creative director: **Garson Yu**
Executive producer: **Claire O'Brien**
Associate producer:
Ryan "Reno" Robertson
Designer and typographer: **Yolanda Santosa**
Designer and animator: **Etsuko Uji**
3D artist: **Nate Homan**
Shake artist: **David Fogg**
Editor: **Zachary Scheuren**

BROADCAST AND COMMERCIAL

When I was in college, broadcast design as a discipline didn't exist. It was the early 1980s, and there were no Macintosh computers, no classes in broadcast design and no job listings for designer/animators. Inspired by the motion design of Saul Bass, my days at school were split between two buildings: the communication arts building, where I majored in graphic design, and the photographic arts building, where I attempted to extend my print design assignments into motion in one of the few ways we could at the time – by exposing motion picture film one frame at a time on a £5,000 Oxberry animation stand. Then, in my senior year, I heard the late computer graphics pioneer Robert Abel speak on the advances being made in animation. It was clear that we were on the cusp of monumental change, and I wanted to be a part of it.

Artists and designers in general are a breed that thrives on the idea of uncharted possibilities. This pioneering spirit is particularly strong in those of us drawn to broadcast design. With every new tool, from the groundbreaking Quantel Paintbox of the 1980s through the million-dollar digital composting systems of the 1990s to today's versatile desktop arsenal, television graphics have been fuelled by the allure of new creative possibilities.

The innovative tools developed for television graphics have attracted designers and artists from a variety of disciplines. Some of the early broadcast designers on the scene were illustrators attracted to digital paint systems that first appeared in television production. Others gravitated to broadcast design by way of print or animation or film-making. All shared a passion to create beyond the limits of their traditional media.

As a result of this confluence, broadcast design has evolved into something requiring an amalgamation of talents. Today a seasoned broadcast designer is expected to command a baffling array of professional abilities that include, among others, the typographic chops of a print designer, the motion and timing smarts of an animator, the stylistic rendering talents of an illustrator, the narrative skills of a writer or editor, the music sensibilities of a composer and the cinematic and live-action directing abilities of a film-maker. With every project a different balance of skills is required. Career paths, too, can be very dynamic. I've known many who have entered the field through one area of expertise and moved on to another.

The television industry itself has gone through changes that have in many ways influenced the development of the work we do in broadcast design. Some areas of broadcast design are independent of the networks. Commercial work and music videos, for instance, are highly creative segments that emphasize visual innovation and narrative. More and more clients are turning to broadcast design firms for these services, owing to our unique hybrid of skills and the consumer's insatiable appetite for ever more compelling imagery and storytelling.

As artists and designers we love the ideas of communication, meaning and expression. I've heard the phase 'nothing is new' many times in my career. On one level it's true. You're selling a product. You're selling a television show. You're illustrating a song. In the end, as it was before, as it will be in the future, the expression is what creates much of the distinction.

Dan Pappalardo
Troika Design Group

Troika Design Group
ABC 'Yellow and Black'

STUDIO PHILOSOPHY

Troika's approach to design aims to deliver imaginative concepts while remaining faithful to the client's brand ideals. The studio has worked closely with top television and cable networks including VH1, FOX, ESPN, HGTV, E!, ABC, Entertainment, Food Network, UPN, Comedy Central, Fine Living, TV Guide Channel and Great American Country.

CREATIVE PROCESS

ABC's classic 'yellow and black' network identity, which aired between 1998 and 2002, incorporated a reductive design aesthetic that was inspired by Paul Rand, the designer of the ABC logo. Design decisions were dictated by four steadfast rules: be real, be honest, be smart and be fun. Colour was limited to flat yellow and black, graphics were deliberately simple and unadorned, and the stars of the shows were featured in a *cinéma vérité* style, using sequences of

black-and-white still photography, all playfully choreographed to percussive music.

'From a designer's standpoint, the creative limitations that are imposed by these rules appear stifling at first. But in fact the opposite is true. The rules stimulate creative solutions because they bring focus not only to the brand but also to the creative process', explained Dan Pappalardo, co-founder of Troika and the project's creative director/designer. 'A well-defined restricted palette guides design decisions, and forces one to be even more innovative.'

This project proved particularly inspiring creatively for Troika because ABC was willing to take risks and do something new with their brand. The black-and-white still photography, the understated nature of the design and the rawness of the look and sound were all bold steps for a network. This identity was evolved each season to align with the network's marketing goals while keeping true to the creative guidelines.

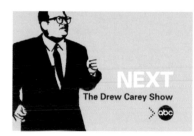
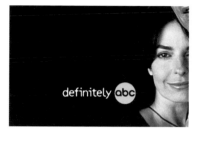

This look also represented the beginning of a shift in the prevailing design style within broadcasting at the time. Throughout the 1990s the focus had been on increasing high-production value with effects-driven designs. The ABC 'yellow and black' network identity ushered in the trend toward flat motion design that continues today.

PRODUCTION PROCESS

One of the hallmarks of the ABC identity was the use of sequential black-and-white still photography. These 35mm stills were shot in collaboration with photographer Norman Jean Roy. Each year, Troika and Roy would shoot around 100 of the network's stars over a three-to-four-day period, resulting in over 30,000 images over the five year period the identity ran. Troika and Roy's idea was to set up scenarios for the talent to improvise and then capture 'moments' that felt genuine and un-staged. The photos were selected, scanned, retouched and edited to create mini-narratives for IDs, opens, bumpers and promos.

The graphic elements of the design were reduced to the circles that form the ABC logo and limited to a flat yellow and black colour palette. No gratuitous information or decoration was included in the design. The animation was raw and full of quick cuts, driven by percussive music tracks in an eclectic range of styles that always concluded with the network's four-note mnemonic signature. A traditional 'hard sell' voice-over was eliminated in favour of more entertaining, musically driven scenarios.

Preserving the real, honest, smart and fun attitude of the network was the key to the success of this campaign. The evolution enhanced the strength of the brand by sticking to its raw elements: no voice-overs, a yellow colour palette, black-and-white photography and a no-frills approach to its clean, spare design.

TOOLS

After Effects, Illustrator, Photoshop, Final Cut Pro

CREDITS

Creative directors and designers: **Dan Pappalardo, Dale Everett**
Designers: **Pamela Haskin, Reid Thompson, Matthieu LeBlan**
Talent photography: **Norman Jean Roy**
Composer: **Mad Bus Music**

Troika Design Group

ESPN – SportsCenter

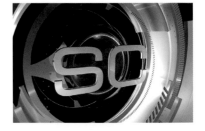

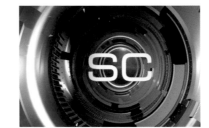

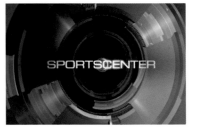

CREATIVE PROCESS

Created for the sports television network ESPN, this 720p high-definition graphics package was the first of its kind on the network. Troika worked closely with ESPN to understand the complex creative and technical demands of the project. The theme that ties the graphic elements together is 'Revolution', represented by a massive 3D turbine that symbolizes the '360 degrees' of sports coverage on ESPN's flagship show. According to Mark Bohman, creative director and Troika co-founder, 'the turbine visually articulates the tension and dynamics of sport and the range of emotions an athlete or fan experiences, from power to agility to anticipation and exhilaration.'

The metallic turbine rotates in a high-tech-inspired 3D space that takes viewers from the team and player logos to sports highlights and onto the SportsCenter set. The futuristic graphics are used throughout the show, with hundreds of elements that brand and package the information featured on hours of daily broadcasts worldwide. Signature logo animations, transitions, teases, franchises and promotional elements create a unified look and identity for SportsCenter.

PRODUCTION PROCESS

The new look for SportsCenter was set to premiere as part of ESPN's first telecast from its new state-of-the-art digital broadcasting centre in Bristol, Connecticut. The new parameters of HD challenged Troika to revisit conventional design and motion options that defy the capabilities of NTSC. Down-conversions and centre extractions for standard definition needed to be factored in, but the designers were able to come up with something innovative in terms of sports packaging, producing a result that is amazingly detailed and adds function to the programming itself.

Delivery of elements was complemented by detailed usage guidelines to maintain consistency across the show and its franchises. Implementation meetings were conducted on-site with various groups at ESPN, explaining the concept and branding principles, to allow for the growth and evolution of the package.

TOOLS

After Effects, Illustrator, Photoshop, Alias Maya, Final Cut Pro

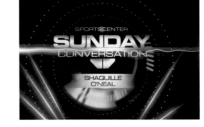

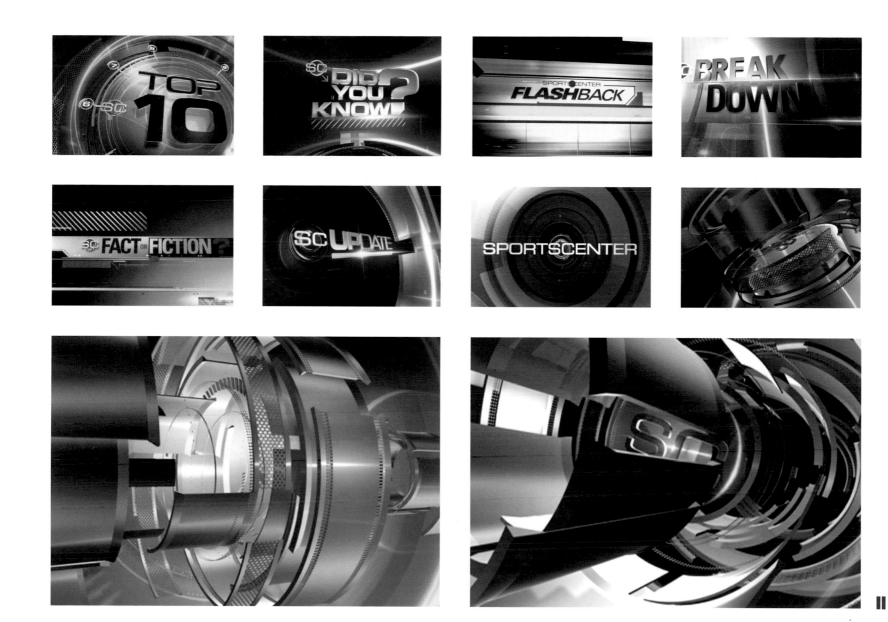

CREDITS

Creative director: **Mark Bohman**
Lead designer: **Gil Haslam**
Producer: **Kristen Olsen**
Designer: **George Malanche**
Franchise animator: **Cory Strassburger**

Package animators: (Drive Studio)
Marco Bacich, Nick DiNapoli, Matthew Green

Troika Design Group
TV Land

CREATIVE PROCESS

The promotional campaign for the TV Land network brings the tagline 'Take Me to TV Land' to life while promoting the cable network's line-up of classic re-runs. The 30- and 60-second spots integrate show footage and hundreds of layers of graphics to create a seamless environment where nostalgic television characters from the 1950s, 1960s and 1970s come together in each of the four individually-themed spots.

The creative challenge that the Troika team was presented with was to create mini-narratives combining clips from classic programmes, animation and existing brand elements to promote 20 different shows. 'Our approach focused on highlighting the personalities and era of each show while creating an abstract visual journey. The spots are driven by show soundbites and the use of a 3D graphic world to transport the viewer literally and metaphorically to TV Land.'

To sell TV Land executives this concept, Troika presented a 5-foot-long storyboard that illustrated a left-to-right progression through four different genres (the 1950s, kitsch, the Wild West and fantasy.) The storyboard set the tone for the final spots and was actually used as an animation element in the final clips.

PRODUCTION PROCESS

Troika's team reviewed hours and hours of footage from hundreds of episodes of the network's vintage programmes to identify soundbites and sequences that illustrated the story of the journey through 'TV Land'. The results of that process provided the framework for the promo scripts for *Everything Television*, *Kitsch*, *Classics* and *Zany Comedy*.

Beloved television characters such as the Fonz, Archie Bunker, Lucy, the Bradys, the Munsters and many others are superimposed with whimsical 2D and 3D graphic elements that are laid out along a scrolling visual timeline interspersed with clips from the vintage shows. Hip, upbeat tracks that are peppered with signature soundbites from the classic characters tie the elements together. The sorbet-hued colour palettes in these spots evoke a Pop art, nostalgic feel that remains true to the sentiment of the network itself.

Editorial and artful compositing was also key to the success of these spots – and in keeping consistent with the theme of each clip.

TOOLS

After Effects, Illustrator, Photoshop, Final Cut Pro

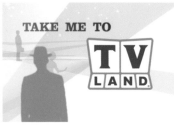

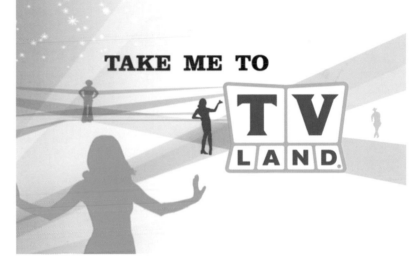

FULL STORYBOARD

CREDITS

Creative director: Sonia Lamba
Designers: **Sonia Lamba, Richard Eng**
Animators: **Jayson Whitmore,**
Richard Eng
Editors: **Luis Martos, Bryan Hargrave**
Composer: **Robert Cairns**

Addikt Design Movement

Addikt 2004 Leader

STUDIO PHILOSOPHY

Addikt Design Movement spares few words on theory, summing up their approach to design with the simple statement 'Let the style tell the story.'

CREATIVE PROCESS

The studio wanted to create a 30-second animation as the leader for their showreel DVD. They wanted it to show Addikt's design skills as the keystone of the studio's work, and to demonstrate the group's skill in combining 2D and 3D animation techniques. They also wanted the leader to have an international appeal, so the style of the animation was much more important then the storyline, which is about a journey through a semi-graphic 3D world in search of the (former) Addikt logo.

'The idea was to make the animation slightly surreal by using a combination of live action, Photorealist elements and pure graphics. The viewer enters the world of Addikt by going through a typically narrow Amsterdam alleyway. We used pictures of Amsterdam buildings, people and streets to create our own version of the city.'

The Addikt motto – 'Design Movement' – also had to feature in the animation, so they decided to map some 'Design Movement' graphics on the 3D walls

and make the camera dart about as though looking for the logo.

PRODUCTION PROCESS

Addikt began the project by taking photographs of some of Amsterdam's best-known modern buildings. Then they rough-modelled them in Maya and used camera mapping to place the images over the models, so the buildings and the car were not really mapped in 3D. 'We created an illusion of texture by projecting the image onto the model to suggest 3D space. The alleyway sequence was shot with a Sony DV camera. We keyed it in After Effects and then tracked the motion in PFHoe. This meant we could apply the graphics on the wall with Maya.' The whole scene set-up and camera movement were done in Maya, and then everything was composited in After Effects.

TOOLS

After Effects, Illustrator, Photoshop, Maya, PFHoe

CREDITS

Director: **Sander Lipmann**
3D modelling and animation:
Koen van Ovoorde
Graphic design and compositing:
Barry Schwarz

Addikt Design Movement
Casema

CREATIVE PROCESS

Casema is a Dutch cable TV company that owns the physical television cables. BSUR advertising agency came to Addikt on behalf of their client, Casema with a concept and a style proposal for the advert, the straightforward aim of which was to make the cable service look good.

The creative process was one of trial and error. Addikt began by making a storyboard based on the client's brief, so that people could really start to think about the project, about what would work and what wouldn't. 'The storyboard had to be changed a couple of times because the clients weren't sure about the message they wanted

to convey. When we finally got approval for the storyboard, we were able to start animating.'

PRODUCTION PROCESS

The first step was to do the tube animation in C4D. Then the transitions were sketched out in After Effects and had to be approved by the client. 'Of course, we went back and forth a couple of times.' After they had been approved, the transitions were done in C4D and combined with the rest of the animation. The whole thing was then fine-tuned and composited in After Effects. 'We put some lights in the background to give the animation more depth and to make it look warmer.'

TOOLS

After Effects, Illustrator, Photoshop, C4D

CREDITS

Director: **Koen van Ovoorde**
Production: **Miranda Vermeer**, BSUR
Art director: **Rodger Beekman**, BSUR
Copywriter: **Jarr Geerligs**, BSUR
3D modelling and animation:
Szann Lipmann
Compositing: **Barry Schwarz**
Sound design: **Larry Soundware**

Addikt Design Movement

Addikt 2005 leader

▶

CREATIVE PROCESS

'While commercial work usually needs to be slick and polished, self-initiated work can be as rough as you like.' To show their stylistic flexibility, Addikt combined illustration with toon-shaded 3D animation for their 2005 DVD reel.

The idea was to make this a loopable animation as a DVD leader. 'There was supposed to be much more illustration in the piece, but in order to have it featured on the Adobe.com website we were bound to a 20-second time limit, so scenes had to be scrapped.'

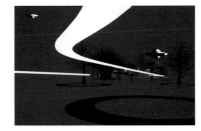

PRODUCTION PROCESS

When Addikt started work on the project, the focus was on creative mayhem and on illustration. But when Adobe.com came into the picture, they had to speed up production and reduce the length of the animation.

The building with the carousel was modelled in Maya. All the illustrations were hand-drawn and scanned in. The animation of the camera path was done in Maya, imported into C4D as a .fbx and then as a .aec exported into AfterEffects. 'It was kind of a hassle, but it tied the whole project together, enabling us to work in Maya, C4D and Afx simultaneously with the same camera.' The illustrations were added in After Effects, and the trees and the bears were done in C4D.

TOOLS

After Effects, Illustrator, Photoshop, Maya, C4D

CREDITS

Director: **Barry Schwarz**
3D modelling and animation:
Koen van Ovoorde and Barry Schwarz
Illustrations: **Sander Lipmann and Koen van Ovoorde**
Music and sound design:
Larry Soundware

Joakim Oscarsson
Je Ne Sais Quoi
'Station to Station'

STUDIO PHILOSOPHY

Joakim Oscarsson's philosophy is to use the power of visual communication to influence, convince and excite his audience. Oscarsson is now becoming more deeply involved in both industrial design and motion design, which he sees as an interesting combination and a sharp contrast. 'Industrial design often deals with "real world" issues such as making products user-friendly, production-friendly and environmentally friendly, while in the motion design world, anything is possible; the only limitations are those set by your own imagination.'

CREATIVE PROCESS

For this animated music video for the song 'Station to Station', Oscarsson worked closely with the band Je Ne Sais Quoi. 'It resulted in a product that communicates exactly what the band wanted to say, the way they wanted to say it, and that is something I found important in this project.'

Oscarsson used a lot of animation to create a feeling of constant forward motion, helped by the use of arrows pointing the way. 'I wanted to give the video a repetitive feeling, a feeling of something going on and on. That is to some extent what I think the song,

the video and maybe the life that some people lead today are all about – a journey from station to station, a constant striving towards the next goal in life. But is this just a rat race, creating ever greater levels of stress? You could say that the video and the song are a critique of modern urban life, asking "Where are we going?"'

PRODUCTION PROCESS

In this project Oscarsson was working with quite a tight budget, since the client is a relatively small independent record label. However, he regarded the task of producing a professional-looking music video with a cheap camera and simple equipment as a challenge. 'The section with the raw DIY feeling to it makes a really interesting contrast to the more polished graphic parts of the video. That is one of the things that makes this production unique and different from most "conventional" music videos.'

TOOLS

DV Camera, digital still camera, After Effects

CREDITS

Design, director and producer: **Joakim Oscarsson**

Mathematics

Betchadupa

'My Army of Birds and Gulls'

▶

All members of the Mathematics team possess a broad skills set from web programming through to design, illustration and animation. This enables them to work in many different mediums, and ensures a vibrant studio atmosphere.

CREATIVE PROCESS

After the studio received Betchadupa's track of 'My Army of Birds and Gulls' from their label Liberation Music, a rough narrative was worked up. The notion of an 'Army of Birds and Gulls' provided the team with a sinister and dark stimulus, alluding to ideas including Hitchcock's *The Birds* which displayed creatures and their hostile relationship with humans. Other stimuli included quite literal and popular associations with birds and flight, such as the phrase "The Early Bird Catches The Worm", shooting, propeller planes and hot air balloons.

Mathematics wanted the clip to share these visual associations with birds, and to incorporate the idea of a mysterious 'army' of birds that would be somewhat unsettling and curious to the viewer, yet at the same time, display the visual detail and beauty of these creatures.

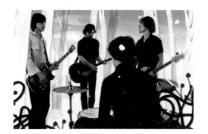

These unsettling themes and associations subsequently flowed through to the visual assets created for the clip, resulting in a wintry landscape with bare trees and a pallette of deep reds, blacks and browns as the subdued backdrop for the band's performance.

PRODUCTION PROCESS

A narrative was established using storyboards. Once this has been translated to a shot list, the band were assembled in green screen studio for one day and performed the song. The footage from this was then edited and keyed. From this point on, the footage and graphics were composited and animated together scene by scene using After Effects.

TOOLS

After Effects, Illustrator, Photoshop, DigiBeta Camera

CREDITS

Director and producer: **Mathematics**

Mathematics

Evermore

'Dreams Call Out To Me'

CREATIVE PROCESS

The studio began by listening to the song and talking to the band about how they saw the music video and how it would fit in with the overall concept for the album. 'As the song is about dreams, we were able to explore many ideas based on surreal scenarios, creating some interesting environments. We worked on a treatment that involved a complex storyline; this was submitted, and with a few alterations the pitch was accepted. While we were working on the story, an illustrator was also working on visual style frames.'

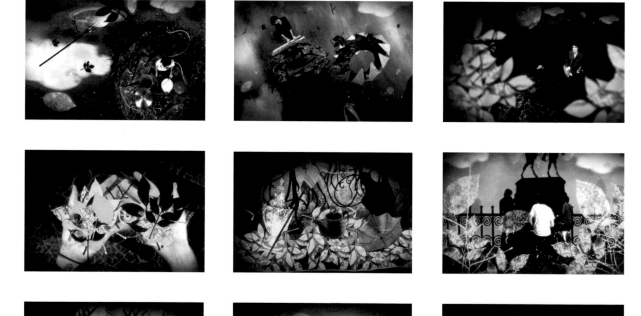

BL:ND
Fameless

STUDIO PHILOSOPHY

BL:ND's founding principles have allowed them to evolve gradually over the years. 'Creatively, we provide smart solutions, with a multi-skilled team able to work in a wide range of styles. For each project we seek a distinctive, fresh approach, making each product unique.'

CREATIVE PROCESS

Creature Films had approached BL:ND about creating a show package for *Fameless*, a comedy series for the VH1 network about 'might-have-beens' who missed the chance for stardom at the crucial moment. The studio realized that conceptually their client's approach had affinities with comic books, in that they were seeking a very stylized method of storytelling. 'Comics are an amazing medium in which design, cinematography and illustration naturally combine. Creatively, this was a great starting-point in terms of thinking how to design the show package. Our aim was to create a product that conveyed the idea behind the show, but which additionally served as a memorable and functional toolkit.'

PRODUCTION PROCESS

Although the design was visually flat, BL:ND explored ways of giving the scenes a sense of three-dimensionnality and creating a sense of space. 'We wanted to get a style of animation that would look like an excerpt from a comic book. We modelled all the characters and elements in 3D and shot a few of our creatives (with DV cam) by acting out scenes outdoors. This footage served as a rough version of the motion captured in the animation.'

TOOLS

After Effects, Illustrator, Photoshop, Maya

‖

PRODUCTION PROCESS

Production started with creating
storyboards based on the approved
treatment. The studio also created
several 3D animatics to help them
with camera moves and transitions.
A studio was booked, and the band
performed in front of a green screen.
'Using a crane, we were able to move
the camera around the band, creating
some dynamic shots. After mattes
were pulled from the footage, the
band were placed into the 2D and 3D
environments. Although most of the clip
was created in After Effects, several
key shots were constructed in Maya.
A final edit was built in Final Cut Pro,
and the clip was cooked.'

TOOLS

After Effects, Maya, Illustrator,
Photoshop, DigiBeta Camera

CREDITS

Director and producer: **Mathematics**

CREDITS

Creative director: **Thomas Koh**
Producer: **Tonya Wallander**
Designers and Illustrators: **Jason
Cook, Thomas Koh, Steve Pacheco**
Animators: **Jason Cook, Jason Lowe,
Thomas Koh**

FUSE

CREATIVE PROCESS

FUSE, a music-oriented cable TV channel, approached BL:ND when it needed a fresh, original and engaging identity for its new schedule of home-grown content. Inspired by guitar-smashing rock stars, the series of 10-second bumpers sets a rock-and-roll, 3D-modelled robot against a psychedelic dreamscape. With a guitar, or even just its own bare metallic fists, the posturing robot trashes the city of 'squares' beneath it. 'The look of the ad was designed to be eclectic and fun, combining 2D-sketched elements and photographic background with the 3D robot.'

PRODUCTION PROCESS

The studio began by developing the design of the characters featured in the series. The robot was then modelled in Studio Max, and several animation cycles of smashing and kicking were created. The robot was then combined with 2D animation and digital photos in After Effects.

TOOLS

After Effects, Illustrator, Photoshop, Maya, Studio Max

CREDITS

Executive producer: **Santino Sladavic**
Art director and designer: **Erik Buth**
Designer and animator: **Felipe Posada**
3D animator: **Ehren Addis**

Jet

'Look What You've Done'

CREATIVE PROCESS

The director Robert Hales approached BL:ND with an idea for a video with an apparently peaceful and harmonious storyline, which would then get turned upside down. The inspiration for the video came from Disney and other cute cartoon characters. 'We began digging up reference material to develop the overall look and style of the animation. We referenced animated feature films, drawings, colour palettes and compositing techniques. From there we began in-depth sketches of our vision of the story.' It was important to make the piece as convincingly cute, charming and authentic as possible, in order to maximize the effect of it being transformed into something dark.

The team at BL:ND continually added more and more to the project. 'Having a bunch of people with very different talents and skill-sets, we were able to develop the project into something very rich. As we got going, each person served as a catalyst for the others' ideas. The combination of illustrators and 3D animators created a balanced piece that was as analog as it was sophisticated in its visual effects.'

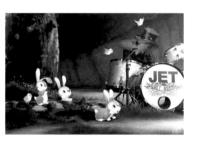

PRODUCTION PROCESS

The production process was a blend of methods, seeking to create a finessed animation that felt authentic to the old-school style of animated cinema. BL:ND began with the development of the main characters, sketching out different angles and moods for each animal using pencil and paper. 'Basically we were using the original production process to create a piece that resembled the old style of animation. The environments were painted in Photoshop as flat pieces, to which we would eventually composite our animations. Our pencil designs for the characters were then re-rendered in Illustrator to define colour, shading and line weights.'

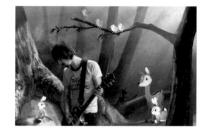

To animate the characters the studio used a combination of vector and cell animation. Some characters and elements were modelled and animated in 3D and rendered with toon shaders. This combination of 2D with 3D blurred the distinction between what was flat and what was three-dimensional, which in turn created a piece with a lot of depth.

'Before shooting the band on green screen, we developed storyboards to flesh out the video shot for shot. All the completed back-plates were brought to the shoot to allow us to view a real-time composite via video tape. After the shoot we colour-corrected the film to help marry the colours to the paintings we had created for this virtual set.'

 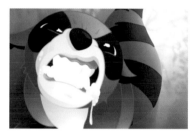 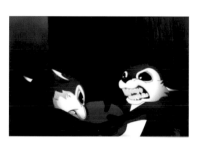

What really helped make the composite convincing was the incorporation of atmospheric elements such as light wraps and particles which allowed the band to interact naturally with the animation.

TOOLS

After Effects, Illustrator, Photoshop, Maya, Discreet Flame, Studio Max

CREDITS

Executive producer: **Ellen Stafford**
Creative director: **Thomas Koh**
Producer: **Ian Dawson**
Designers and illlustrators: **Michael Zimmerman, Bill Sneed, Thomas Koh, Lawrence Wyatt**
Animators: **Lawrence Wyatt, Bill Sneed, Thomas Koh, Christian de Castro, Atsushi Ishizuka, Jason Lowe, Wonhee Lee, Owen Hammer, Delphino Gamboa**
Flame artists: **Joel Ashman, Elton Garcia**
Director: **Robert Hales, Crossroads/Merge**
Director of photography: **Sam Bayer**

 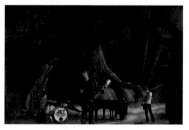 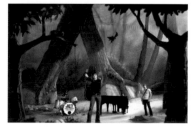

Buraco de Bala
Beija Sapo

STUDIO PHILOSOPHY

Buraco de Bala's origins as a group of students from the Universidade de Brasília continues to inform the way they work, welcoming whatever technical challenges need to be met in order to accomplish their goals. 'We always find a way to make our ideas reality, irrespective of whether our computers are up to the job. Our philosophy is: if we have to do it frame by frame, using the most old-fashioned technique, then that's what we'll do. As we've always been a small group, we really believe in relying on our own resources.'

CREATIVE PROCESS

The members of Buraco de Bala have known each other for a long time and have never drawn a line between friendship and work; over the years a lot of ideas have been discussed formally and informally.

When MTV Brazil's creative director, Rodrigo Pimenta, approached the studio looking for a show opener for a programme called Beija Sapo (*Kiss the Frog*); Buraco de Bala already had some sources and design concepts they had been discussing informally that seemed to fit the job perfectly. The opener had to relate in a classical way the fairy tale suggested by the programme's title. 'As he spoke, we swapped ideas among ourselves –

things like "medieval art" and "automata" – and these actually encapsulated how the video turned out.'

Beija Sapo's opener grew out of the fact that Buraco de Bala had a limited amount of time to produce what was then their most important job to date, and they needed to show what they were capable of. So they decided that by using simpler, more automatic animation techniques they would be able to concentrate on refining the visuals in order to create a high-quality final product.

'Since we were dealing with the plot of a fairy-tale, 14th-century etching and Hieronymus Bosch suggested themselves as sources to establish the mood.'

They chose a music box as the device that would generate the narrative, beginning with an image of the machinery within the box, and ending with the revelation that the machinery and story all took place within a tiny music box. For the story that unfolds from the music box, they settled on a cartoonish 2D style with a layered, 3D feel. The overall look, the music box and music all helped create a 'once upon a time' atmosphere.

PRODUCTION PROCESS

The studio had a three-week schedule from the day they closed the deal to the last day of production. In those three weeks they had to create all sorts of things for the ID: logo, bumper stickers, various styles for character displays, a video panel for the show's background, closing credits and the show opener itself.

'So we called some people from the design studios we are partners with and put together a crew of eight people for the job. We had a sort of assembly line to produce the many drawings used in the video, plus two people applying and animating all of the illustrations in a 3D environment.'

To produce all the material Buraco de Bala used just a rough drawing of the music box's components and machinery, instead of a storyboard. The whole narrative is based on how a real music box would behave. In terms of building the set, they had full-size theatres in mind, as many real stages are equipped

with a network of rails for scene changes and so on. 'Production and creative processes really go side by side in our working method; production being a matter of transforming the planning into the finished product, with every detail sharp and crystal clear.'

TOOLS

Photoshop, After Effects, Audition, Illustrator, 3D Max

CREDITS

2D illustration: **Emerson Luiz, Aleixo Leite**
Clean-up: **Letícia Luna**
Painting: **Daniel Barroca, Daniel Grilo**
3D: **Bruno Rojas, Sílvio Nóbrega**
Music: **Samuel Lobo, Rhudra**
Sound effects: **Daniel Luna**

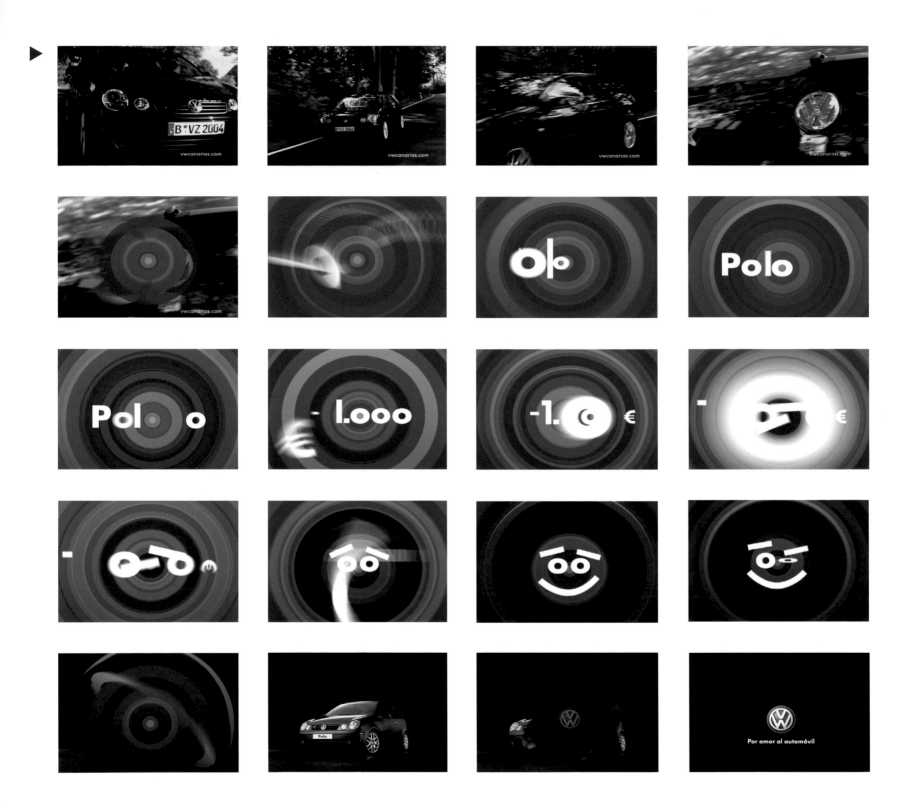

Volkswagen Polo

CREATIVE PROCESS

When the studio was given the initial briefing for this TV spot, it also received a storyboard. After some discussion Buraco de Bala decided to suggest something slightly different. Analysing the brief, it was decided that the key elements were to make the word 'Polo' change first into '1000' and then into a happy face and to end the advert with a shot of the car.

The ad was based on the perfect sync of animation and sound-track. Colourful 'disco-style' graphics, quick type movement and exciting, upbeat music worked best for the effect the studio was trying to achieve. These elements combined to create an atmosphere that conveyed the feel of an enjoyable car ride with good music playing in the background.

After a few conversations with the agency, the vectorized illustrations of the car were replaced by a few live-action takes. This made the whole idea come together, as it gave the audience the chance to picture themselves driving their own VW Polo.

PRODUCTION PROCESS

The typography was designed using basic shapes; all the characters were either based on a circle or had long stems. The clean, geometric type forms worked perfectly to make the happy face at the end, and worked well with the disco background.

The background was conceived as a series of superimposed circles, whose colours interact with each other as they change in size to the beat of the music. The scale animations were made using key frames generated by the beat itself, using a sound interaction plug-in.

'Using the circles as a background made it easy to come up with effective and simple creative ideas. We opted in the end to have them spinning around on their own axis. The agency was so pleased with the visuals that they ended up producing printed promotional material based on the video.'

TOOLS

Photoshop, Illustrator, Audition, After Effects

CREDITS

Agency: **Dr. Job (Canary Islands)**
Creative director: **Dr. Job**
Design: **Buraco de Bala**
Animation: **Buraco de Bala**
Music: **Samuel Lobo**
Sound effects: **Daniel Luna**

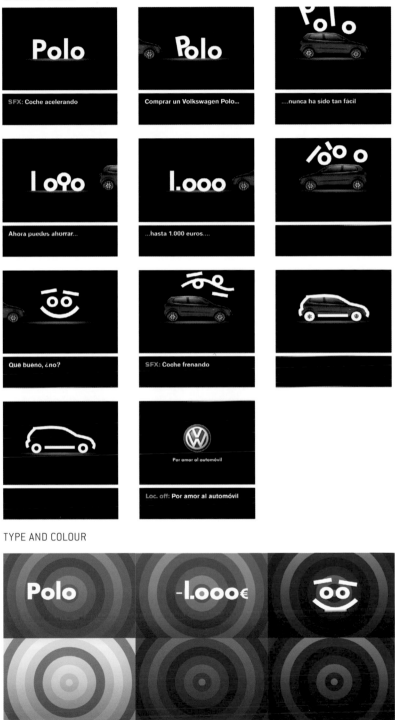

ORIGINAL STORY

SFX: Coche acelerando

Comprar un Volkswagen Polo...

....nunca ha sido tan fácil

Ahora puedes ahorrar...

...hasta 1.000 euros....

Qué bueno, ¿no?

SFX: Coche frenando

Por amor al automóvil

Loc. off: **Por amor al automóvil**

TYPE AND COLOUR

Foreign Office
Blue Guru

STUDIO PHILOSOPHY

Instinctively driven by the desire to communicate visually as well as conceptually, Foreign Office create imagery infused with their hallmark spontaneity and energy – 'without external influence or restrictions of media, using attitude, humour, daring, clarity, obscurity, technology and truth.'

A common thread in Foreign Office's conceptual approach is a humorous, at times facetious, combination of the visually absurd and improbable. Visual elements are juxtaposed and combined in a virtual genesis that makes maximum use of motion in order to bring unification by design. 'Our philosophy lends itself to a less cautious approach, allowing for a degree of spontaneity as each piece develops and starts to take on its own personality and purpose.' The studio prides itself on the technical mastery that has become one of its trademarks.

CREATIVE PROCESS

While designing the website for Blue Guru Clothing in the UK, Foreign Office were asked to create a piece of animation that would be viewed online or downloaded from the site.

Blue Guru is a 3-minute animated short based on the premise that, contrary

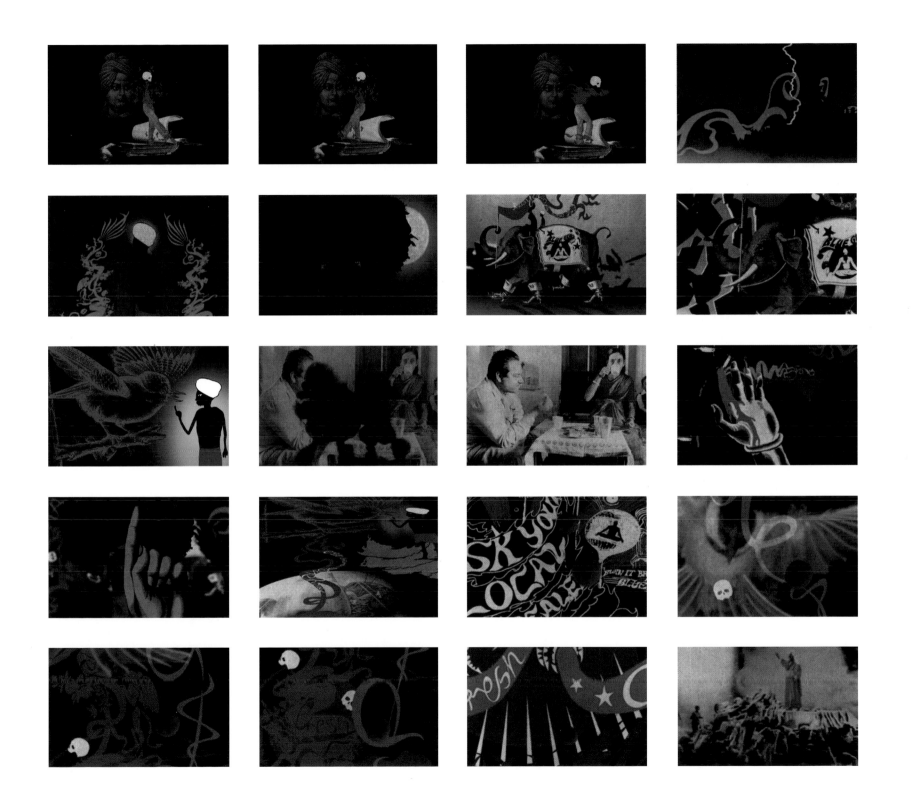

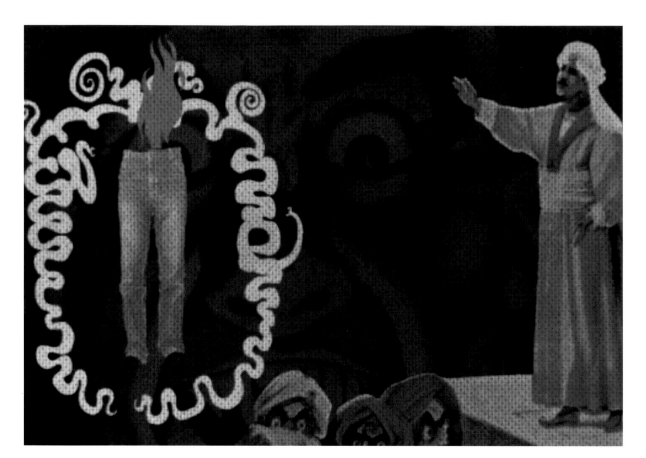

The visual material and all components were scanned and logged. The voice-over track was also divided into segments. In this instance one director, who combined and animated the various scenes using several software packages, tackled the main creative process.

The final stage was the import of the animation via a series of image sequences into an editing package. Technically, delivery of this piece was for the Web, and thus the final edit was off-line quality and done in-house.

TOOLS

After Effects, Illustrator, Photoshop, Flash

CREDITS

Direction, animation and editing:
Foreign Office

to popular belief, denim originated in India. The animation begins with a British TV news style voice-over telling how 'denim connoisseurs, travelling across North America, came across an ancient piece of cloth that dated back one thousand years'. Wrapped within was a section of parchment, on which was old Hindi text telling the story of 'Blue Guru'.

The story continues with an Indian voice-over, recalling how a shaman gave a small boy a brew from local indigo plants. This gave the boy indigo blood, which by chance fell on to some cloth many years later. The boy went on to develop a new type of

robe that had legs for himself and his friends. The boy's name was Deenum Jareem, but he came to be referred to as the 'Blue Guru'.

PRODUCTION PROCESS

Instead of any literal interpretation, the journey is more a collection of visual reactions to the story, and it is mainly the dialogue that creates a sense of conceptual flow. Foreign Office edited the submitted script to fit within a 3-minute format before recording any of the vocal tracks.

'With the voice-over laid down, we began the creative process by

accumulating a library of images – the client was asked to submit examples of artwork used or generated for promotion purposes.'

From this image bank emerged a series of vignettes based loosely on the dialogue, but primarily inspired by the images themselves. At times simple word association is used to allow surreal leaps of imagination that precede sequences of sublime logic. One such example is that of the marching elephant. A single image triggered this Terry Gilliam-inspired sequence, which has become symbolic of the entire piece.

Foreign Office
MTV A-cut

CREATIVE PROCESS

Foreign Office was handed a brief with a loosely defined, but simple objective: to illustrate in the packaging of an MTV programme the process of taking an unknown band and 'making it into something' – thus the studio hooked onto the concept of transformation and used this as its conceptual base.

The idea was to attract an existing audience of 15- to 25-year-olds to a competition. The overall philosophy was one of inclusion, where they would feel compelled to participate: a creative process that targeted the inner vision, dreams and fantasies of the bands, brought to life through the use of animation over live action.

Foreign Office had to ensure that its translation of the brief did not reflect a style that fell outside the client's existing format: an interesting challenge, as any studio would naturally want to create something unique and fresh.

Early presentations to MTV Networks Europe (MTVNE) focused on the combination of actual footage and illustration. A series of stills were used from edited-down footage provided by MTVNE of bands performing in a generic sound studio. Following initial client feedback, Foreign Office shifted its attention to characterization. An important aspect of the overall concept was to depict the 'size' of each band's ambition. The studio pushed the boundaries of exaggeration as far as possible, to assess the client's limits and the strength of the concept.

Final presentations involved the refinement of combining animation with the live footage. In this case the animated sequences were done with

a loose form of rotoscoping, where the digital artwork was drawn directly on top of the live action. This made integration of the animated graphic and footage quite easy. The director drew inspiration from the energy and movement of the various performers.

PRODUCTION PROCESS

Once the creative idea had been approved, the list of deliverables was defined on a full cross-media brief that also involved some print. The broadcast deliverables were a programme logo/identity, a title sequence, bumpers (front and back clips that lead into and out of programming material) and an end-board. Foreign Office also created the sponsorship bumpers for the show's main sponsor, Vodafone.

Production began on the title sequence alongside preparation of the artwork for print. The identity, already approved during the presentation phase, was adapted for broadcast.

'We elected to continue to use the footage provided by MTVNE and broke it down into segments. Digitized versions of the shots were then converted into low-resolution frame sequences that made it possible to animate over each individual frame.'

'Animation, although traditional in nature, was executed by means of a digital tablet directly into an animation software package. Final graphic frame sequences were imported back into the edit suite, composited over the live footage and prepared for output to broadcast PAL.'

Audio for the main title sequence, also done by Foreign Office, was an inter-cut taken from the footage of the various bands' performances. The remaining preparation of material, bumpers and end-board, was a matter of editing and adapting the original sequence.

TOOLS

After Effects, Flash, Wacom digital tablet

CREDITS

Direction, animation and editing: **Foreign Office**

Foreign Office
MTV Load

CREATIVE PROCESS

MTV Networks Europe (MTVNE) was hosting content on its own WAP portal, but needed a vehicle to market the ease of access to the user's own mobile entertainment. Motorola, in turn, were looking for a way to market their new range of mobile handsets that acted as a showcase for their latest features.

An important element of the visual concept was 'somehow to reflect the viral marketing aspect of the campaign. The aim was that one user would access material, and the content would then be shared and passed on to other people. The philosophy is best described as MTV Load being fertilized by Motorola.'

Foreign Office's interpretation was that of germination – the seeds of an entertainment portal are sown, and a scattering of content and users eventually grows into a forest. The 'all-seeing eye' as a symbol was used in a fresh way and incorporated with maximum effect: 'the combination of hand and eye is a visual metaphor for the interaction of the senses when accessing the content via a mobile handset.'

PRODUCTION PROCESS

'What they [MTVNE] wanted was for an on-air identity that would introduce the overall concept via a range of teasers and stings that would be spread across MTVNE's programme schedule.' After a brainstorming session and exchange of ideas, a series of presentations followed in which the studio presented its collective response to the brief. 'As this was aimed at an audience across several countries, we decided we needed to communicate the Load identity clearly without the need for text.'

The project was subsequently divided into a series of shots and sequences that were used for the launch of the on-air segment of the campaign. For the *Load Forest* (on-air promotion) campaign a collection of 2D design elements was designed to comprise layers of the forest floor, following which an artist used Maya to create a 3D flower that pops up to reveal Load footage within its centre.

Using 3D layers in After Effects, the final shot was composited into a sequence of events with the 'camera' travelling through a forest of black weeds.

All audio effects were added along with the Load content in an off-line

edit at the studio. Later a final image sequence and audio files were sent to a facility for final conform.

For *Tattoo Hand with Eye* (the main programme titles) a painted flower design is shown growing up the hand, much like the roots of a forest. After it had been shot and removed in stages via a digital mask, the sequence was reversed and integrated with a traditionally drawn eye and a Maya orbital particle light effect. Again all elements were composited within After Effects and later sent to a facility for final conform.

The *Hand and Eye* Composite teaser was the most visually striking of all the shots created for the on-air segment of the campaign. It was shot on digital on Colorama backgrounds then keyed out and composited together in an Inferno system. Foreign Office did an offline edit only for client approval, and the later Inferno work was done at a separate facilities house. All audio and voice work was directed by Foreign Office.

The client also requested a separate short movie for Motorola handsets. This was *Fighting Flowers*. A storyboard was handed to the Maya artist along with a briefing on look, feel and mood

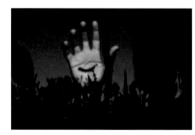

from the director. The flower design and construction were left to the 3D artist, who submitted samples at regular intervals.

TOOLS

After Effects, Maya, Flash, Inferno, Mental Ray, Wacom tablet, Colorama, Inferno

CREDITS

Direction, animation and editing.
Foreign Office

Tommypost
Discover Card

STUDIO PHILOSOPHY

Tommypost's aim is to be a pioneering influence in digital motion graphics – exploring fresh ideas and discovering new creative and technical solutions. 'In motion graphics you don't get a second chance from the audience', Tommy notes. With that in mind he strives to create powerful, emotional experiences that resonate with viewers from the moment they encounter his work.

CREATIVE PROCESS

'This job for Morgan Stanley was a great opportunity and challenge to create a one-minute broadcast commercial for Discover Card's electronic billboard in Times Square, New York. The billboard measures 55 feet by 55 feet and is seen by 1.5 million people every day and 30 million tourists a year. In that environment you never know when the audience will look up at the screen. It could be at any moment. You can only do your best to catch their attention when that happens and hold it to the end.'

This led to three strategies:
'First, because the split second when a person looks up at the billboard is my only opportunity to grab their attention, and because there is little chance they will notice the details, I decided to use a simple, line-based graphic style with a high-contrast colour theme.

Second, in order to keep the audience's attention throughout the commercial, I used a dynamic combination of custom graphics, video and 3D artwork to create the animation. I was having fun animating with different transition styles while staying true to the requirement of the brand.

Third, following the Discover Card brand guidelines, messages are consistently delivered through plain white text on a solid colour background. The message therefore needs to be striking and clearly readable at a distance.'

PRODUCTION PROCESS

Flash was the main tool used to execute this piece and After Effects was used to combine video clips into it and visually enhance it. Swift 3D was used for all of the 3D aspects.

TOOLS

After Effects, Illustrator, Flash MX, Swift 3D

CREDITS

Designer and producer: **Tommy Korad – aka Tommypost**

mateuniverse
Funkstörung
'Dirt Empire'

STUDIO PHILOSOPHY

Mateuniverse is a multidisciplinary team specializing in moving imagery. In terms of style, their approach is contemporary and experimental within the given limitations of the professional environment.

CREATIVE PROCESS

The track *Dirt Empire* by German electro band Funkstörung is reminiscent of the psychedelic music of the 1960s, and the images in the video also refer to art of that decade. From the vague sense of anticipation provided by the blurry haze at the beginning, graphic patterns develop into more and more solid forms. During the course of the video these take on the shapes of contemporary architecture. The video then zooms out from buildings and houses to show a city skyline. As Jan Mathias Steinforth of mateuniverse explains: 'The transformation from organic form to square buildings symbolizes how remote today's "First World" culture is from its origins.'

PRODUCTION PROCESS

The piece was generated in a digital environment, incorporating natural phenomena. The masks for the buildings was ink filmed underwater, then recycled, cut up and distorted, to form the shape of the architecture melting into the dusky, watery scenario. This piece takes advantage of the latest developments in compositing techniques.

TOOLS

After Effects

CREDITS

Director: **Jan Mathias Steinforth (mateuniverse)**
Music: **Michael Fakesch and Chris DeLuca (Funkstörung) with Nils Petter Molvaer**

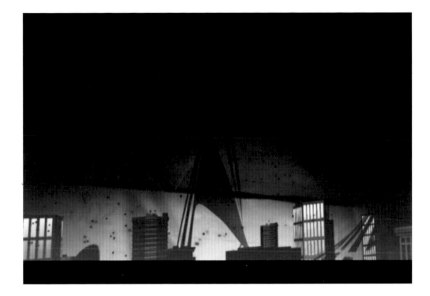

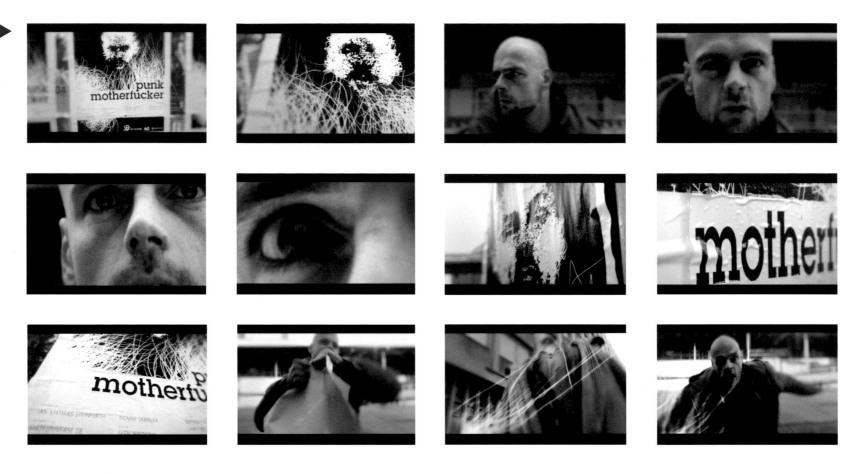

mateuniverse

Funkstörung

'Punk Motherfucker'

CREATIVE PROCESS

A man is walking through an urban setting, putting up posters for the band Funkstörung. The posters show an aggressive face, which suddenly starts screaming at him. He is shocked, but carries on with the job until he gets more and more furious and finally tears up the poster in his hands. At this point the graphic world of the poster starts to interact with the real world, with objects leaping out to haunt the man, who runs away. A chase ensues, which culminates in the man being completely caught up in the graphic world of the poster. 'The theme of the piece is conflict and aggression. As the man reconciles his conflict with the poster, so a sort of reconciliation within himself takes place. The idea is to show that you cannot run away from yourself.'

PRODUCTION PROCESS

Shot on Digital Video, the footage took a huge amount of post-processing and post-production. Nearly every shot was composited, colour-corrected and edited with state-of-the-art digital tools to achieve its unique look.

TOOLS

After Effects, Maya

CREDITS

Director: **Jan Mathias Steinforth** (mateuniverse)
Camera: **Udo Sauer**
Actor: **Ingmar Skrinjar**
Music: **Michael Fakesch and Chris DeLuca** (Funkstörung)
Best boy: **Sven Windszus**

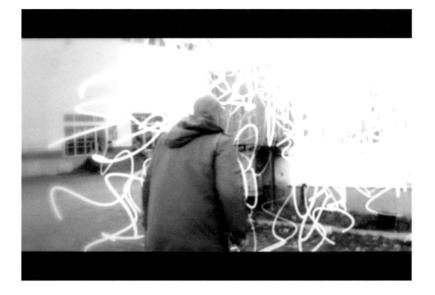

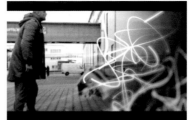

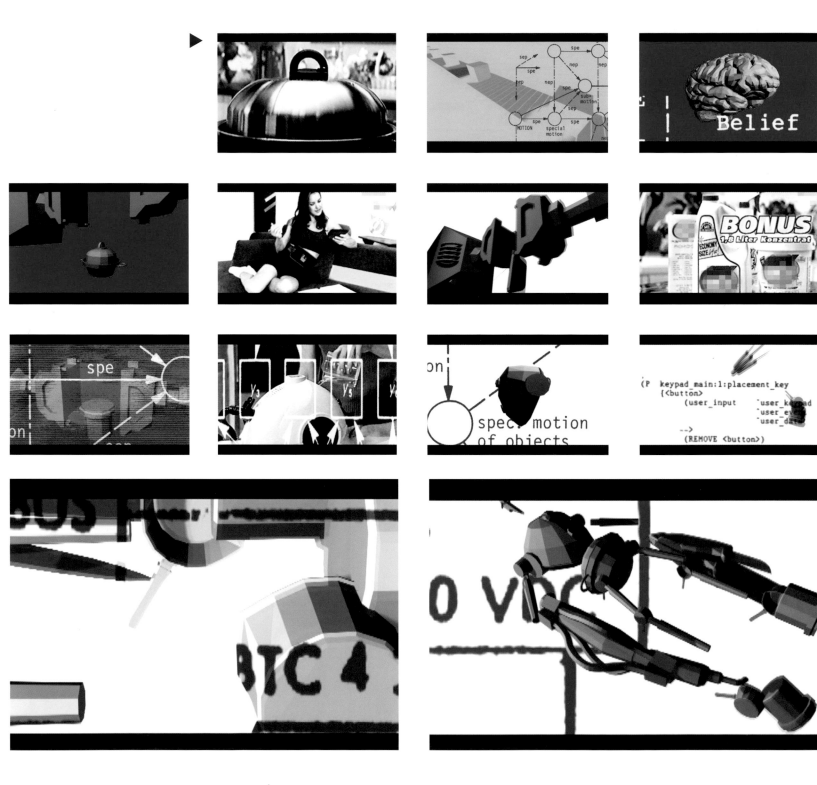

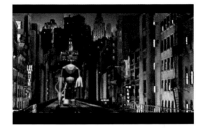

mateuniverse
Riot

CREATIVE PROCESS

We are surrounded by media: magazines, advertising, radio, television and the Internet. Of these, television has the greatest impact. 'What if the things people watch on TV, like nonsensical teleshopping, suddenly turned on the viewers and took over the whole planet. How would people react? This video installation gives one possible answer.'

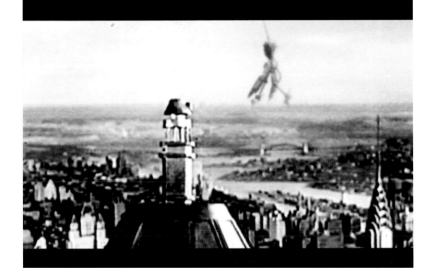

PRODUCTION PROCESS

The basic edit included a lot of found visual footage, which was adapted and modified to fit the concept of the video, using colour correction and other tools from the contemporary digital toolbox. Then 3D elements were incorporated. 'The visual style chosen for the piece was deliberately low-fi, using the digital elements to emphasize the trashy content of the found footage.' The music was tailored to the images; again found musical elements and samples were used, which were than stitched together to form a sound collage.

TOOLS

After Effects

CREDITS

Director: **Laserluchs**
Animation: **Jan Mathias Steinforth**
(**mateuniverse**)
Edit: **Alex Schmidt**
Music: **Kaikabase.de**

Feedbuck Galore
Hands

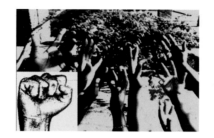
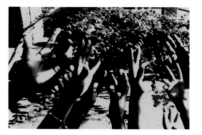

STUDIO PHILOSOPHY

Feedbuck Galore want their use of art and technology 'to make the world a more beautiful place'. Diversification and innovation have been central to their approach ever since the partnership's early days doing video gigs at underground art events. They now have a wide-ranging portfolio that includes projects in the music, theatre and fashion industries.

The studio combines cutting-edge technology with traditional media, happy to fuse analog and digital, art and architecture. At the heart of the enterprise is a desire to take video art out of the studio and away from the screen, to create performances that will entertain audiences throughout the world.

CREATIVE PROCESS

Hands is a small part of a larger video art installation project, Going 4 a Million, that came about because of Jon Buckley's interest in animating still images. For the past few years he has been making small QuickTime films based on net searches. He started to download images from the net to further his experiments. 'Early on I ran into a website with 12,000 images of sci-fi magazine covers (philsp.com). I read the designer's prophetic quote: "I never meant to get in this deep". Phil, I feel your pain. In six days I downloaded ten thousand images. The images only rarely animate in the

traditional sense, but as I watched this early assemblage my ideas about animation began to change. I think that I started to detect feelings from this massive data stream. I started to see an-i-ma-tion.
1. The act, process, or result of imparting life, interest, spirit, motion or activity.
2. The quality or condition of being alive, active, spirited or vigorous.
3a. The art or process of preparing animated cartoons.
3b. An animated cartoon.
Not in meaning 3 but in meaning 1, I felt like Dr Frankenstein, so in true mad scientist fashion I cranked my monster into the lightning-filled skies.'

PRODUCTION PROCESS

Buckley's goal in undertaking this project was to animate random images through web searches, to try to create animation out of chaos. The process started by choosing the subject – hands. The images were downloaded, stripped of their file names, randomly renamed as a number and imported into QuickTime. 'The photos were scaled and ordered by the computer and, while not really random in the mathematical sense, it was out of my control, so chaos crept in and soon things started to make sense.'

TOOLS

Photoshop, Alta Vista, QuickTime, Safari, Sitesucker

CREDITS

Concept: **Jon Buckley**
Animation: **Melissa Kaminsky** – aka **Missy Galore (Feedbuck Galore)**

Psychedelic Drip

CREATIVE PROCESS

Inspired by the psychedelic art of the 1960s, Jon Buckley wanted to create works full of light and colour that would 'uplift the spirit with their vibrant beauty'. Major influences were the organic abstract imagery of Harry Smith and Joshua Lights.

'Today multimedia is a technologically driven form, dominated by machine-processed content and algorithms. I love computers and dedicated outboard gear, but there can be something cold in that process. With *Psychedelic Drip* my interest was in creating handmade artwork that would resonate instinctively with the viewer: 21st-century arts and crafts as cyberlicious, down-home pixel fun.'

'I had done some 16mm optical printing, and I knew about the technique of bowls within bowls of colour, oil and water placed on overhead projectors to create the light shows of legend, but I did not have those tools at my disposal; I had to replicate them.' Updating and integrating these processes, Buckley collaged acetate photocopies of food colouring, oil and spices in 35mm slide frames.

Buckley says the physical act of working on pieces this small is pure artistry for him. 'Not only am I determining the composition by what is placed where – there is an additional element of object density and how various layers filter into each other. This is essential when going to the next step: animating these images as video. Using an Espresso slide-to-video converter, all my adjustments read in real time. Shapes and texture splurge and converge as zooms, focus and f-stop alterations play collage together the way a guitarist plays his axe.'

PRODUCTION PROCESS

Food colouring, oil, vinegar and cooking spices were placed in clear plastic zip-up bags. These in turn were printed onto clear acetate using a colour photocopier. The resulting sheets were then collaged into 35mm slide frames with scissors and clear tape. Displayed as still art and within multi-channel projection installations, these images convey a sense of the micro/macro fractal parallel – as if one is simultaneously looking through a microscope and a telescope.

At the time colour photocopies were a relatively new technology. 'I remember the difficulty I had in getting the prints. The bags were full of movement as the food concoctions swirled about inside them. With so much liquid people feared their photocopiers would be damaged. By wiping the bags clean first, and claiming that they didn't leak, I could get the shop assistants to copy them, but I could only go to each copy shop once. The results were luminous still lifes of frozen motion, the hidden language of cooking supplies.'

Espresso changed everything. That analogue slide-to-video light-box converter opened the door to real-time video integration. *Psychedelic Drip* owes its existence to this method. Slides animated on the Espresso were fed into a video mixer and combined with video feedback. This integration

creates seamless, unpredictable flows of colour and texture whose sense of movement mimics the undulating pulses of moving water: flowing over river rocks, dancing down waterfalls.

Screened as original artwork, integrated into projection installations and mixed as virtual light-show layers for live video performance, the gracious motion of these materials is still inspiring today.

TOOLS

Plastic bags, photocopiers, Espresso slide-to-video animation, light-box with analogue conversion, Panasonic MX 30 with Custom Proc Amp Mods, cables, power

CREDITS

Animation: Missy Galore – aka Melissa Kaminsky (Feedbuck Galore)

LOWER EAST SIDE

Charming, loft style studio
renov, Oak Floor, Laundry, pets OK
Available Immediately
No Brokers Fee. 698-9238

Manabu Inada
Drifting Resident

Furn'd Apartment
Beaut Lounge Chair, Sofa

STUDIO PHILOSOPHY

Inada design studio communicates on a very intimate level with both today's youth market and the general consumer. 'Acting as a creative think-tank, we're able to capitalize on our firm's multicultural DNA by dissecting a design challenge from many different vantage points. Having understood the client's needs, purpose and market, we apply our acute sense of trends and cultural shifts to a dynamic and precise, concept-driven design that will hopefully enthuse and engage the audience.'

CREATIVE PROCESS

Drifting Resident is a short film introducing innovative approaches to residential spaces that was made for the 'B Hotel' exhibition at P.S.1 Contemporary Art Center, New York, in 2002. Manabu Inada was personally responsible for all the creative work for this piece. 'The greatest challenge in this type of work is to bring a concept to life as clearly in production as in the imagination and in sketches. I spend most of my time on this stage of the process, and once I have thought through every detail, the actual production stages can be completed quite quickly.'

Inada came up with the original concept of a man living inside a water-tower, as though it was just another form of urban dwelling, when he first moved to New York in the early 1990s. 'This mile-high landscape of battered water-towers and long-gone industry made such as impact on me that the story popped into my mind already written, edited and finalized.'

'At the time using the water-towers seemed very analog to me, because it provided comment on the digital super-highway movement that was driving anything non-digital into the East River.'

The story is centred on a man who lives in a number of different locations, depending on how his needs change. A water-tower, a subway car, a shipping container all become as 'normal' as a flat on the Lower East Side, only more suited to his lifestyle. The narrative pays homage to the film *Taxi Driver*, from which it borrows the tempo and dark undertones of urban life in the hustle and bustle of modern Manhattan.

TOOLS

After Effects

CREDITS

Director and producer: **Manabu Inada**
Voice-over: **Vincent Keane**

Manabu Inada
Arashi Wo Yobuotoko

CREATIVE PROCESS

This piece of animation was created for the 'Motion Graphics 2000' exhibition in Tokyo. 'It is based on a typical over-the-top karaoke video: it is a parody of the trendy sing-along entertainment found in bars all over the world. The setting is designed as a complex, overlapping 2D city, with 3D typography and a protagonist who is superimposed around the city and is as outrageous and engaging as the animation itself.'

PRODUCTION PROCESS

Production involved just Manabu Inada and his colleague Vincent Keane, who played the character in the movie. 'After storyboarding the shots and photographing Vincent, we then started shooting between downtown New York and Brooklyn, using a digital camera. Once we had the shots we wanted, we combined the images into individual sequences in Photoshop, using layers.' The pictures were edited as an animation in After Effects, and then all brought into Final Cut Pro for final production.

TOOLS

After Effects, Illustrator, Photoshop, Final Cut Pro

CREDITS
Director and producer: **Manabu Inada**

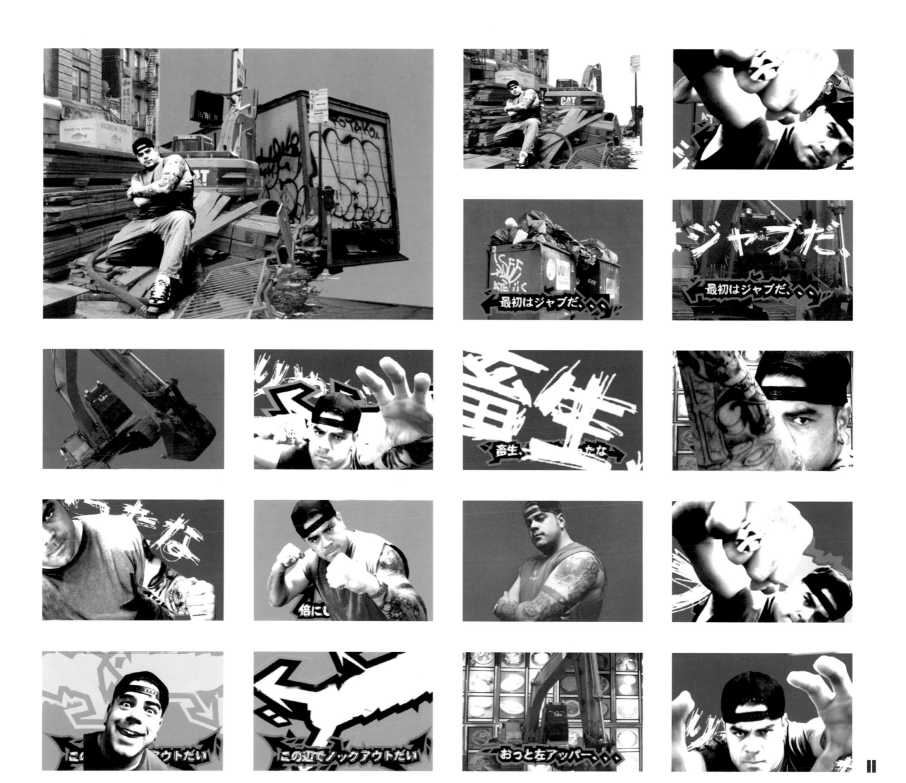

PSYOP
Nike Shoxploitation Trailer

STUDIO PHILOSOPHY

PSYOP's studio philosophy is mostly about pushing themselves and their work, and trying to have fun while doing it. 'We have come to realize that if you do something half-heartedly it always ends up being a complete waste of time, not just half-wasted but fully wasted. So we feel that when we get into a project we really need to give it everything we can; creatively, technically and emotionally. It's very intense, but we all seem to like it that way ... We have table football and a pack of dogs in the studio to keep us light-hearted.'

The name PSYOP was appropriated from the identity of the United States government's division of psychological operations. 'We like to think that it represents an awareness of the power that advertising has. We also borrowed the slogan that they have on their emblems, surrounded by a lightning bolt: "Persuade, Change & Influence!"'

CREATIVE PROCESS

Nike came to PSYOP with the request to create four short films inspired by the 'blaxploitation' films of the 1970s such as *Shaft* and *Superfly*, using four of their star athletes. The studio saw it as a chance to create a bunch of fun, action-packed, loose narratives. 'There was so much animation necessary on that job that we had to do motion capture. We have found that this is a great tool to get the basic sense of motion, but we always end up going back into the motion curves and tweaking them. We found ourselves forced to take short-cuts on that project, using 2D matte paintings wherever possible, creating 2D particle effects etc., but it seems to have added a rawness to the visual quality that we like. I think we produced five minutes of animation in eight weeks.'

PRODUCTION PROCESS

The job involved an incredibly fast turnaround, with some significant deliveries. 'It's difficult to remember the details of the process now because humans like to forget the pain! After a couple of rounds of the old back and forth, we finalized some story ideas and started on production. From that point on it was a sprint. We did a lot more of our environments in 2D, which was new for us. Most of the animation was motion capture, which kept things fast and efficient.' The most time-consuming part was the compositing. 'We had all these different sources – 3D, 2D, photographed textures, cg particles, shot particles – and we needed to blend them all together to make an aesthetically pleasing interpretation of "blaxploitation" poster art. We have always found it to be more challenging to create coherent interpretations of reality versus Photoreal iterations of it. When you make the sky orange, you've got to figure out what colour to make the ground.'

TOOLS

After Effects, Illustrator, Photoshop, Autodesk Flame, Particle Illusion, SoftImage XSI

CREDITS

Directors: **Kylie Matulick, Todd Mueller**
Executive producer: **Justin Booth-Clibborn**
Producer: **Boo Wong**
Associate producer: **Joe Hobaica**
Writer: **Steve Raymond**
Storyboard: **Ben Chan**
Editor: **Jed Boyar**
Character, prop and background designers: **Brian Wood, Toby Cyprus, John Frye, Daniel Piwowarczyk**
Graphics designer: **Pal Moore**
Graphics animator: **Jonathan Garin**
Senior 3D artists: **Domel Libid (lead), Todd Akita, Marko Vukovic, Vadim Turchin, Eric Lampi, Brad Friedman**
3D animators: **Jason Goodman, Maurice Caicedo, Alvin Bae, Gerald Ding**
Modellers: **Paul Liaw (lead), Jun S. Myers, Junguen Kim, Lee Wolland, Josh Harvey, Marcelo Cermak**
Compositors: **Eben Mears, Aska Otake**
Mocap: **Perspective Studios**
Rigging: **Sylum**
Sound: **Jed Boyar (music producer), Risa Neuwirth (production), Studio G**

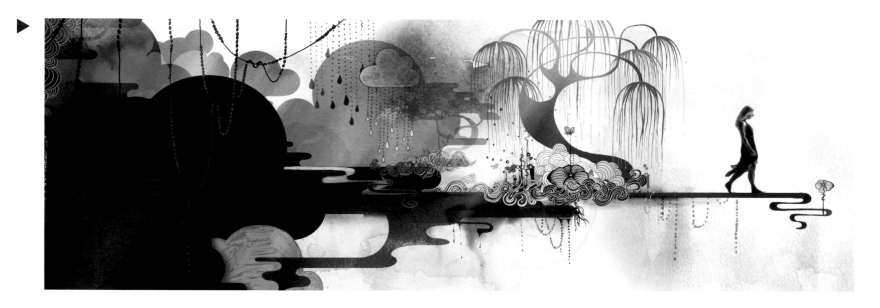

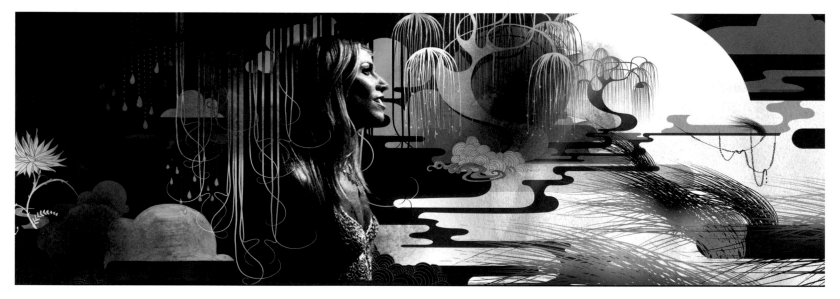

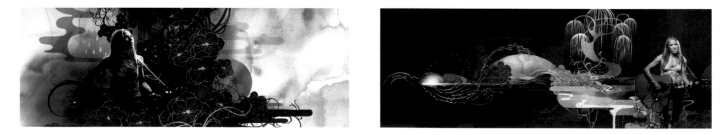

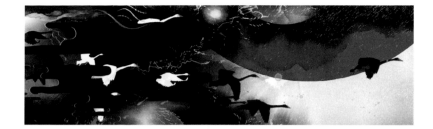
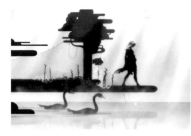
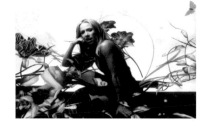

PSYOP

Sheryl Crow

'Good Is Good'

CREATIVE PROCESS

The music video commissioner approached PSYOP with Sheryl Crow's song, thinking that their approach would be perfect. 'Kylie [Matulick] and I were in Australia vacationing at the time the call came in. Luckily we had our laptops, some painting supplies and a scanner with us, so we had everything we needed to make some lovely style frames.'

PRODUCTION PROCESS

The video for 'Good is Good' began with a 20-hour shoot with Sheryl Crow only a week after PSYOP won the job. All the studio had for the shoot was

their written treatment and a couple of style frames. 'Usually we do extensive pre-visualization so that we have a solid idea for camera motion, lensing and action. For this shoot we had none of that ... Sheryl Crow was really great on set.' Once the film was transferred, the studio still didn't have a solid idea of what they were going to do for the four and a half minutes of song time. It wasn't until they got to their fourth version of the edit that the piece began to take shape. 'At that point we locked the edit and then created something like 62 style frames: one for each scene. Every shot had to be rotoscoped, and the footage wasn't on green screen.

TOOLS
Photoshop, Illustrator, Commotion, After Effects, Softimage XS1, Boujou, Autodesk Flame

CREDITS

Production, design and animation:
PSYOP
Directors: **Kylie Matulick, Todd Mueller**
Flame artist: **Eben Mears**
Executive producers: **Justin Booth-Clibborn, Cath Berclaz**
Producer: **Mariya Shikher**
Live action producer: **Paul Middlemiss**
Lead 3D artist/technical director:
Domel Libid
3D artists: **Chris Bach, Kevin Estey, Alvin Bae, Pakorn Bupphavesa,**

Laurent Barthelemy, Todd Akita, Vadim Turchin, Maurice Caicedo, Eric Lampi, Gerald Ding, Hay-yeun Lee
Junior Flame artists: **Jaime Aguirre, Joe Vitale**
Tracking: **Joerg Liebold, Chris Hill, Jan Cilliers**
Designers: **Douglas Lee, Daniel Piwowarzik, Babak Radboy**
2D artists: **Josh Harvey, BeeJin Tan, Mats Aanderson**
Roto artists: **Chris Halstead, Adam Van Dine, Ella Boliver, Joshua Bush, Chad Nau, Kirstin Hall, Danielle Leiser, Stefania Gallico**
Storyboard artist: **Benjamin Chan**
Editorial: **Wild Child Editorial**
Editor: **Brett Nicoletti**
Assistant editor: **Andrew Giles**

Renascent
Things That Never Existed

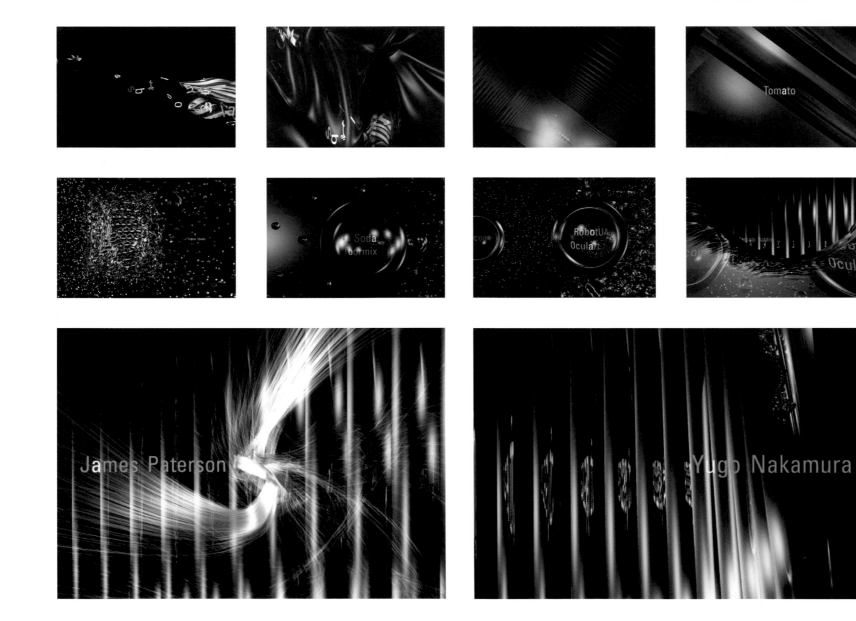

STUDIO PHILOSOPHY

Joost Korngold, aka Renascent, is a freelance motion designer/director who constantly strives to inject his compositions with a precise balance of passion, vision and metaphor. He has created logo animation for Konami's 'Metal Gear Solid 3' video game, a cinema commercial for the Spanish culture magazine *AUX*, and an ad for Eroski supermarket in Spain.

CREATIVE PROCESS

Renascent was asked to create the main opening title animation for the 2005 OFFF festival of digital arts and electronic music in Barcelona. The animation had to include the names of all the artists whose work was to be presented at the festival, and to play on the relationship between art, thought and digital technology, which was the event's focus.

The theme of OFFF 2005 was 'Things That Never Existed'. Korngold chose to

explore it as follows: 'I wanted to create a dreamlike world with seamless transitions from one environment to the next, suggesting the abstracted and metaphorical environments that the artists live in.'

PRODUCTION PROCESS

The production process involved creating these surreal environments in 3D Max. Various 3D Max plug-ins were used, such as Sim Cloth, Glu3D, RealFluw and Shag:Hair. Colour correction and post-edit was done in After Effects. The result is a beautifully understated piece that effectively explores the creative possibilities of contemporary design.

TOOLS

After Effects, 3D Max

CREDITS

Designer and director: **Joost Korngold**
Music: **Marcelo Baldin**

Stylorouge

Mariesas/ReMasterpiece

STUDIO PHILOSOPHY

In whatever media they work, Stylorouge's priority is effective creative communication. Each project the studio undertakes is treated on its own merits and according to its unique requirements. 'We aim to think about everything we do laterally, and avoid complacency about what one might think is the natural way to arrive at a creative solution.' The first stage of every job is research: about the product, the market, the client and the creative possibilities that may be available. 'A lot of our work is

commissioned within the music and entertainment industry, and to avoid the possibility of repetition it is essential to find unique qualities in the subject and bring those through in the final product, whether it be a website, a TV commercial or a print campaign.'

Stylorouge say they are very aware of the cross-media potential of communication today, and have an unhealthily voracious interest in investigating this potential and in encouraging clients to look at their own projects in a similarly open-minded manner. Brainstorming follows the briefing and research stages, and during it the optimum creative team for the project will be selected, or in many cases select itself.

CREATIVE PROCESS

This piece of work was born out of a packaging design project. 'As the artists are predominantly studio-based and are not easily able to promote their music in a live context, we recommended this promo clip and an accompanying website to the client.' An early animation test and a storyboard

were produced, and on approval of this the elements were illustrated and, where appropriate, built in 3D ready for the animation. These tasks were shared by Christopher O'Hare and Nigal Raymond.

PRODUCTION PROCESS

'The original concept was to visually illustrate a journey through nature to technology, which reflects the similar marriage of the organic and the mechanical in the music itself. The clip was to be about fluidity and evolution.' An initial storyboard was created to help plot the viewer's journey through the constantly evolving illustrative landscape. It was then broken up into separate scenes to correspond with specific musical cues contained in the track. Next, each individual graphic element was created and animated in Cinema4D and 3D Studio MAX, based closely on the original illustrations and Photoshop work. Finally compositing and post-production were completed in After Effects to achieve the final grade and edit.

TOOLS

After Effects, Illustrator, Photoshop, Cinema4D, 3D Studio MAX

CREDITS

Music: **Chris Coço and Sacha Puttnam**
Director: **Christopher O'Hare**
Illustration and animation: **Christopher O'Hare and Nigal Raymond**
Creative director: **Rob O'Connor**

 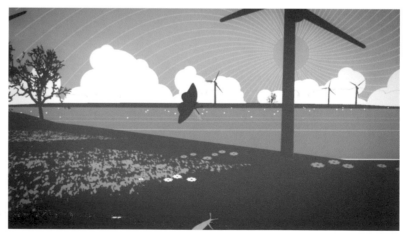

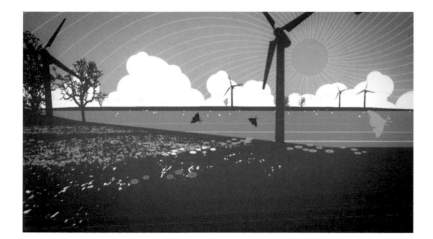

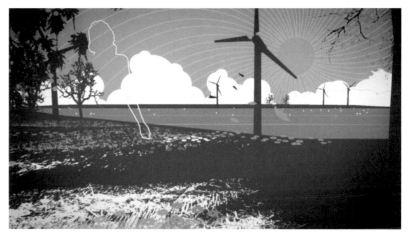

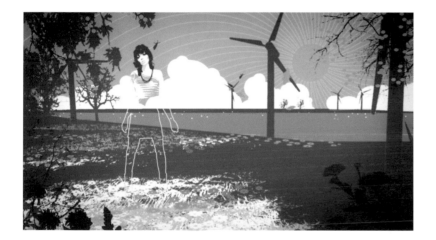

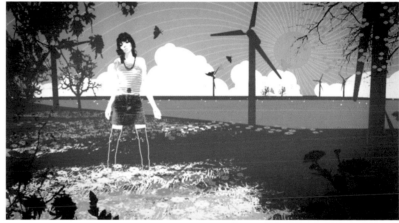

Stylorouge
Stylorouge title sequence

CREATIVE PROCESS

This piece was created as a short title sequence to front the Stylorouge showreel. The animation was made from an original illustration that had been commissioned from Steven Wilson, which was initially used for the cover of Stylorouge's company brochure. 'The idea was to produce a visual journey through an illustrative 3D environment that literally created itself around the viewer.'

PRODUCTION PROCESS

From a technological/process point of view Steven Wilson's original illustration was taken and broken down into its component elements and layers. It was then reformatted and reassembled within a 3D environment, gradually building up the elements in layers to re-create the original illustration with depth and perspective. Each separate element (wind turbines, flowers, trees, clouds etc.) was then individually animated in After Effects or 3D Studio MAX to reveal itself in a fluid and decorative way as the camera journeys through this fictional world, before finally coming to a rest as the main character and the company typographic are created to complete the piece.

TOOLS

After Effects, 3D Studio MAX

CREDITS

DVD build and authoring: **Nigal Raymond**

Stylorouge
Zena Holloway

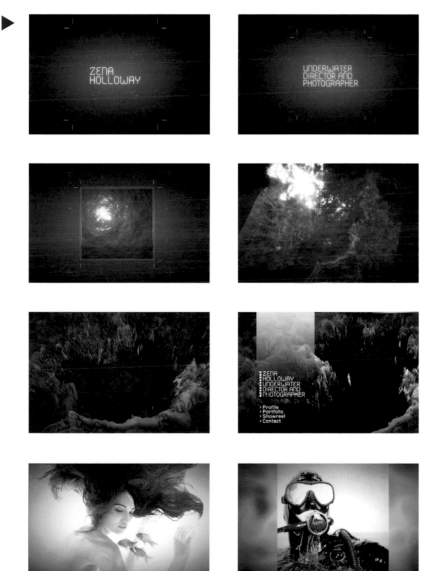

CREATIVE PROCESS

Zena is an underwater photographer and director. For her first promo DVD, Nigal Raymond, who created these animations, suggested not using her own footage except within the showreel itself, thereby implying the underwater content of her work without compromising its value by sampling it for this use. Actual underwater topographies were researched and specific locations chosen for these environmental 'swim-throughs'.

PRODUCTION PROCESS

A high level of skill and technical knowledge is required to be a successful underwater photographer. The visual elements in this piece combined art and science and referred to technologies of diving such as radar, sonar, depth gauges and computer-generated visual representations of unseen underwater topography.

The entire project was developed after first researching the science and visual language of diving and underwater photography. This was then used to create a fictional topographical slice into the earth's ocean floor and sea-beds in a 3D environment. High-resolution textures were created and applied to complex 3D meshes, followed by the addition of caustic effects and particle systems to enhance the perception of depth and detail. Separate areas of this environment were then selected to reflect each section of the DVD showreel. Multiple camera passes and renders were created and composited in After Effects to achieve the final look, and the full showreel was then encoded, built and authored in Apple DVD Studio Pro.

TOOLS

After Effects, Apple DVD Studio Pro

CREDITS

Illustration, animation and DVD build and authoring: **Nigal Raymond**

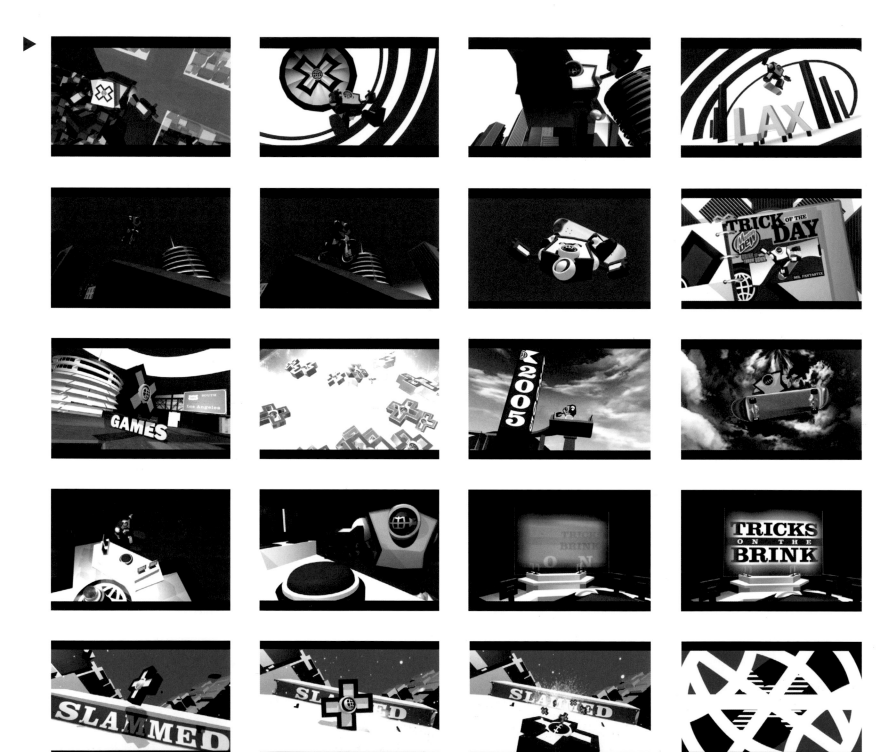

V12
X Games Winter/Summer '05 ESPN

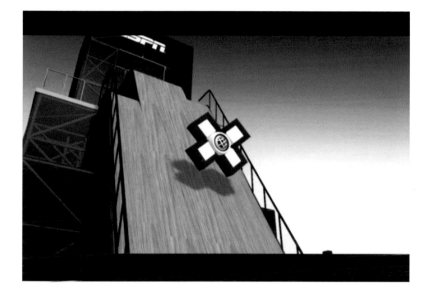

V12 is a BRANDESIGNIMATION ™ company specializing in television commercials, network on-air packages, main titles and promos.

Founded in 1998 by design director David James Hwang, a former co-founder of highly regarded Two Headed Monster, along with design director David Sparrgrove, producer Jennifer Lucero and editor Alex Recsan, V12 are practitioners of the 'Engage and Communicate' method, where ideas and messages are enforced by appropriate, influential form and attractively executed.

CREATIVE PROCESS

Extreme sports require high-octane graphics, and V12 won the decisive victory from a competitive pitch put forward by the US sports channel ESPN. The X Games is an annual multi-sport event with a focus on action sports including skateboarding, surfing and skiing. Replacing the X Games' institutional but ageing logo, V12's proposed new version was used as a launching pad to create an energetic package for both the winter X games (held in Aspen, Colorado) and summer X games (held in Los Angeles, California).

PRODUCTION PROCESS

The only design/animation company in broadcast design history to win the coveted X Games graphics package consecutively, V12 has created the character of Mr Fantastix, the X Games mascot derived from the new, highly visible logo. The package is held together by this logo and mascot and also by a simple colour palette, and engaging and readable display graphics.

TOOLS

After Effects, Illustrator, Photoshop, Avid Symphony, Maxon Cinema 4D

CREDITS

VP of remote production: **Jed Drake**
Senior co-ordinating producer:
Rich Feinberg
Creative director: **Noubar Stone**
Creative producer: **Jeff Wilkov**
Chief creative officer: **David Hwang**
Executive producer: **Jen Lucero**
Executive creative director:
David Sparrgrove
Senior producer: **Susan Harris**
SUMMER lead animator: **Tom Allain**
Animator: **Thomas Kurniady**
Junior animator: **Michael Moore**
WINTER lead animator: **Tom Allain**
Lead animator: **Hsi-Ming Hsiung**
Animator: **Wilson Wu, Calvin Lo**
Junior animator: **Justin Blythe, Michael Moore**

V12
ESPN NBA

CREATIVE PROCESS

The National Basketball Association approached the sports channel ESPN asking for something new and completely original in terms of basketball broadcast graphics. V12 met the challenge with a package that redefined sports graphics and ESPN's own look.

PRODUCTION PROCESS

Using a 3D technique trademarked as Uber-3D™, V12 tapped into the 'super-slick, stylish, jazzy roots of the NBA'.

Swooping shapes, generous use of black negative space and creative typography are the hallmarks of this package: 'high-end bling for a cool and unpredictable sport'.

The ESPN NBA graphics package was created by a team of directors and

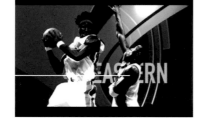

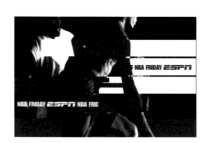

animators at V12 using Photoshop, After Effects and Maxon Cinema 4D, working in collaboration with ESPN.

TOOLS

After Effects, Illustrator, Photoshop, Avid Symphony, Maxon Cinema 4D

CREDITS

Senior co-ordinating producer:
Jamie Reynolds
Creative directors: **Noubar Stone,
Michael Szykowny**
Associate creative director:
Dan Cunningham
Chief creative officer: **David Hwang**

Executive producer: **Jen Lucero**
Executive creative director:
David Sparrgrove
Senior producer: **Susan Harris**
Animators: **Allen Donhauser, Jason
Rapp, Tom Allain, Anthony Honn,
Camille Chu, Anthony Pauzie, Ehren
Addis, Brian Castleforte**
PLF animators: **Kent Seki, Chris Baty,
Kyle Robinson, Raul Moreno,**
Junior animators: **Michael Moore, Jim
McDaniels**

PMcD Design ▶

Muhammad Ali Center

STUDIO PHILOSOPHY

PMcD Design is a New York-based design firm. Their philosophy is a collaborative one, developing partnerships with clients and creatives. 'By establishing the company on an intimate scale, PMcD cultivates a personal vision for each design task that invites innovation in the development of a shared visual concept for the project.'

A complementary team is assembled from a rich and diverse talent base to ensure that the right tools and talent are joined to the right job. The creative team's involvement in every facet of design and production aims to ensure a consistent and original approach from concept development to final execution.

CREATIVE PROCESS

Rifling through Muhammad Ali's pockets in his early days, you would have found a poem on a crumpled piece of paper. Rudyard Kipling's 'If' became the thematic heart of the Ali Center's orientation theatre film, 'If You Can Dream'. Cortina Productions collaborated with PMcD and built the design from the ground up, creating a signature emotional experience that would set the tone for the entire

museum experience. Motion graphics were choreographed to lead the audience's eyes across five screens playing at once in a masterful dance of thought and word.

PRODUCTION PROCESS

The demands of designing for five simultaneously lit HD screens offered a challenge. From the moment footage was digitized, the project didn't touch tape until the final render. This meant huge files on independent drives had to be shipped back and forth between production offices and finally to Louisville, where the media were installed. Patrick McDonough recalls, 'Despite the complexity of the tech specs, the collaborative teams never lost their velocity or consistency of vision throughout the process.'

TOOLS

After Effects, Creative Suite, Final Cut Pro

CREDITS

Creative director: **Patrick McDonough**
CD/designer: **Suzanne Kiley**
Producers: **Dana K. Bonomo, Wendy Gardner**
Animator: **Sharon Eagan**
Muhammad Ali Center producer: **Cortina Productions**
Director: **Joseph Cortina**
Producer: **Stephen Platenberg**

PMcD Design
Encore Networks

CREATIVE PROCESS

For Encore, PMcD's challenge was twofold: first, carve out this master brand's own unique look and feel, and then use this to unify the flagship service and the six genre-titled networks under one brand banner. For the feature openers PMcD chose visually to play with iconic elements that are part of the cinematic experience for each genre while still articulating their relationship to the overall style. Bold poster type, rich cinematography, vignetting, contemporary letterbox and complementary palettes were used to highlight the personality of each genre, while keeping a familial relationship to the Encore brand.

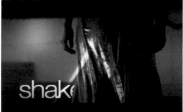

PRODUCTION PROCESS

Original photography was primarily used to create iconic imagery for each genre. Animation of the logo icon into the scenes reflected the mood and tone of each genre. Editorial decisions were made early to allow tracking and rotoscoping of integrated graphics. A glossary of words and phrases captured each network's attributes.

TOOLS

After Effects, Illustrator, Photoshop, Final Cut Pro, Quantel Paintbox

CREDITS

Creative director: **Patrick McDonough**
Director: **Terence Williams**
Designers: **Miguel Hernandez, Sharon Haskell, Alex Smith**
Executive producer: **Dana K. Bonomo**
Producer: **Wendy Gardner**
Colourist: **Tim Masick**
Editor: **Rachel Reichman**
Animation: **Sharon Eagan, Paul de Laubier, Moreno DiMarco, Matt Hanson**
Music: **Tonal**

PMcD Design
Starz
Networks

CREATIVE PROCESS

For any movie channel, the feature opens are the ultimate brand statement. For Starz, they needed a big idea that was both unique and intrinsic to the brand. Establishing the new logo was crucial to the client, so PMcD landed on the star itself as hero and began a visual exploration of its outer and inner properties. 'Compositing graphic elements with live action, we wanted to make these stars ignite, tease, beguile and energize us – much like big-screen movie stars and events do.' Each of the genre sub-brand feature openers are conceived in its appropriate cinematic style, in turns art-house, mysterious, soulful, absurd and late-night cool. While in each genre the

kinetic star illuminates and subtly transforms the environment, it always resolves to the logo. The design for each of the Starz genre channels is strongly linked to the main service, while the palettes and live action clearly delineate their individual personae.

PRODUCTION PROCESS

The challenge of co-ordinating live action, green screen, 3D and 2D animating elements for six channels required continuous communication between remotely located team members. Frames were storyboarded to outline a cohesive flow of each element into the whole. Motion testing for the star throughout the editorial process created a seamless product.

TOOLS

After Effects, Illustrator, Photoshop, Avid, Flame, Soft Image XSI

CREDITS

Creative director: **Patrick McDonough**
CD and designer: **Michael Grana**
Executive producer: **Dana K. Bonomo**
Director: **Terence Williams**
Colourist: **Tim Masick**
3D: **UV Phactory**
Editorial: **Refinery**
Animation: **UV Phactory, In8 Skils**
Music: **RKMusic**

National Television

Exercise Your Music Muscle

National Television's design philosophy is based on creative collaboration, coupled with 'a sense of humour and a desire to work with good people on good projects'.

'We bring disparate things together. We are the United Nations and NPR [National Public Radio]. We are experienced. We love good stories and nice pictures. We are fanboys. We are writers, designers, animators and illustrators.'

National Television pride themselves on not being concerned with whatever is currently considered 'clever' or 'cool'. They are not high-fashion or trendy. 'We are not urban street artists. We are not pretentious. We are not nostalgic. We want to tell stories. We want to make people laugh.'

CREATIVE PROCESS

National Television believe in developing the story, first and foremost, 'to allow for the styles to accent the journey'. Los Angeles based ad agency, Ground Zero, tapped National Television to develop the ground breaking viral game-like promotion titled, *Exercise your Music Muscle*, as its core promotional tool for the pay-for-download music store.

Once National Television had been given a long list of songs that were to be included, they developed the character design, added value to both the overall story and individual song names, then built transitions that led the spot from one portion of the story to the other. Once the character designs were approved, they were placed in the Music Muscle world. Using a romantic, baroque, gilded-era style, they hope 'the piece transcends "cool" territory, defies genre and acts as a catalyst for song names from many different eras in music history to be viewed as a single, cohesive piece.'

PRODUCTION PROCESS

National Television worked with Ground Zero from the inception of the project to add identity, attitude and a unique quirkiness to the project. 'We culled the song list down and used the quick reads and iconic actions that help the viewer play the game without giving too much away. Working with a very talented group of artists, we then stitched segments of completed animation together in a massive animation that was contingent on the previous action to work and re-work the project files.'

TOOLS

After Effects, Creative Suite, Maya

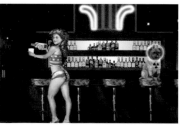
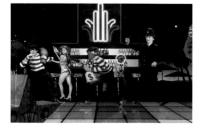
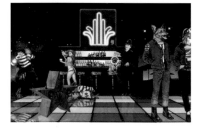

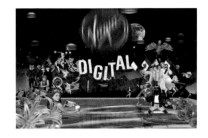
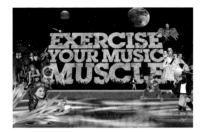

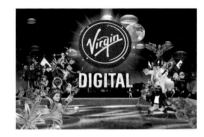

CREDITS

Client creative directors: **Rodrigo Butori, Kristina Slade**
Client producer: **Kat Friis**
Designer and director: **National Television**
Co-creative directors: **Brumby Boylston, Chris Dooley, Brian Won**
Head of production: **Steiner Kierce**
Designer: **Brian Won**
3D animators: **Wonhee Lee, Kevin Walker, John Nguyen**
2D animators: **John Nguyen, Camille Chu, Brumby Boylston**
Additional illustrations: **Ben Lee**

National Television

▶

Observer Food Calendar

CREATIVE PROCESS

London ad agency Mother gave National Television the commission to create an advert for the *Observer* Magazine with the directive: 'Whatever you had for lunch will suffice'. National Television 'ran with the idea to its gluttonous conclusion'. They took the opportunity to collaborate with artists, cartoon illustrators and 3D animators, in line with the company mantra of working with unconventional creative talent. 'We approached this piece determined to create animation that finds reference and inspiration in unlikely sources: in this case a combination of lesser-known Pop artists and hyper-realist painters from the 1970s and 1980s.'

PRODUCTION PROCESS

National Television's designers created a very long Illustrator file to define the elements, actions and attitude of the piece. The elements were then broken down and animated, built, drawn, painted and then recomposited. National's animation team created elements in 3D that were passed on to the 2D director/animators to achieve a superbly tempting effect.

The production began after the approval of the world that was created. The

artists broke the piece down and began
to build each element piece by piece,
with regular meetings and constant
communication with the client and
the various teams. The production's
segmented workflow meant that the
teams would reconvene each evening
to discuss progress and next steps.
'The truly inspiring moments usually
came late at night, when the individual
food elements were composited and the
full beauty of the cascading animation
could really be felt.'

TOOLS

After Effects, Creative Suite, Maya

CREDITS

Art directors: **Stuart Outhwaite,
Ben Middleton**
Creative directors: **Chris Dooley
Brian Won, Brumby Boylston**
Head of production: **Steiner Kierce**
3D animation: **John Nguyen, Ironclaw**
Illustrators: **Ben Lee, Joel Chang**
Post-production: **National Television**

National Television
Nature

CREATIVE PROCESS

Nike approached National Television when they introduced their FREE style shoe – running shoes constructed to feel as though one is running barefoot. The campaign included two spots, *Nature* and *Strength* – both adjectives that add value to the concept of the barefoot running shoe. The studio

began with the concept 'free'. Thinking about types of freedom and analogies with running barefoot, this immediately led to the natural environment as a setting and to the idea of the cycle of life, which echoes through the piece. The project also called for a loopable animation, so this was also included.

PRODUCTION PROCESS

The production process began with a brainstorming session, a main idea and a few sketches of key moments, jotted down in notebooks. 'We collaborate with a few amazing 3D artists who have a keen sense of design and an ability to build animation elements that are beautiful and also able to fit into a 2D composite to stunning effect. There then follows a process of constant communication between the designers and animators, who feed elements, textures and assets to the director/animator, who creates the world and provides the quirky tone of the piece.'

TOOLS

After Effects, Creative Suite, Maya

CREDITS

Art director: **Manny Bernardez**
Creative directors: **Chris Dooley, Brian Won, Brumby Boylston**

velvet mediendesign

e City

STUDIO PHILOSOPHY

Matthias Zentner, designer/director, and Andrea Bednarz, creative director, founded velvet in Munich in 1995. The aim was to take advantage of their different experience, their shared passion for design and quality, and their constant search for new creative stimulation.

Velvet comprises a design studio and film production company. Flexibility is essential to the company's philosophy in order to be able to adapt to the specific needs, target audiences and strategic objectives of each client. 'We create tailor-made design and produce challenging commercials and movies accommodating whatever parameters the client sets in terms of production method, type of project and costs.'

CREATIVE PROCESS

Velvet try to create adaptable and highly skilled creative teams, covering every stage of the production process from original concept to final product. Each project needs its own unique constellation of talents, redefining the job of designers, creative directors, animators, 3D specialists, operators, directors, producers, editors, copywriters, musicians and software developers.

'This teamwork allows us to keep a tight control on the creative process in all its phases and guarantees the quality of the design we strive for. Our goal is to find all-encompassing design solutions in order to implement the corporate design. Original concept and storyboard go together, as do directing and production, editing and post-production. We are technically equipped to finalize jobs in-house, allowing us to meet our own rigorous standards and be in total control of our own workflow.'

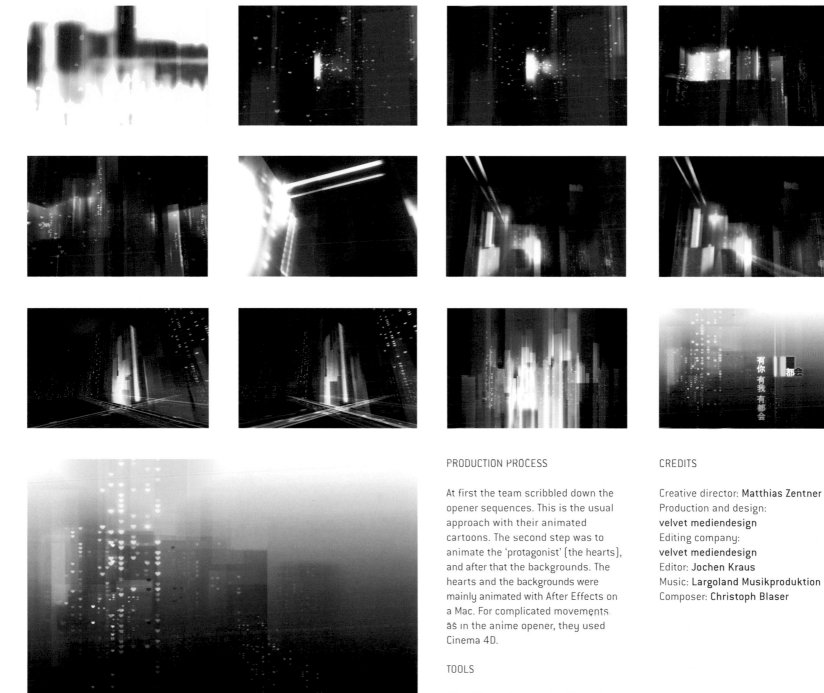

PRODUCTION PROCESS

At first the team scribbled down the opener sequences. This is the usual approach with their animated cartoons. The second step was to animate the 'protagonist' (the hearts), and after that the backgrounds. The hearts and the backgrounds were mainly animated with After Effects on a Mac. For complicated movements, as in the anime opener, they used Cinema 4D.

TOOLS

After Effects, Cinema 4D, Discreet Flame

CREDITS

Creative director: **Matthias Zentner**
Production and design:
velvet mediendesign
Editing company:
velvet mediendesign
Editor: **Jochen Kraus**
Music: **Largoland Musikproduktion**
Composer: **Christoph Blaser**

Poem

CREATIVE PROCESS

The team began with a basic creative idea, provided directly by the Showtime network; there was no agency involved. Using this, they worked on a storyboard and director's interpretation. The rest then took place in co-ordination with the clients.

Poem is velvet's third project for Showtime Beyond (a channel devoted to mystery and suspense programmes). This spot, directed by Matthias Zentner of velvet, reflects a journey through daydreams, nightmares and narrow escapes. 'It transports the viewer to an imaginary place where the imagination catches fire and stories leap to life.'

PRODUCTION PROCESS

The spot was shot in Kiev in just two days. In a very complex post-production process (mostly Flame and 3D) real-film shoot was combined with video effects and animation elements.

TOOLS

Maya, Avid, Discreet Flame

CREDITS

Editor (Avid): **Jochen Kraus**
Online processing (Flame):
Alexander Gabrysch
Director: **Matthias Zentner**
Producer: **Andreas Rothenaicher**
Production: **velvet mediendesign GmbH**
Video effects/Flame:
Alexander Gabrysch
3D: **Blackmountain, Germany**
Music: **Sven Faller, Amazonas Studio**

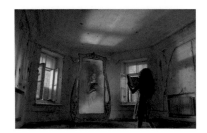
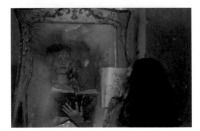

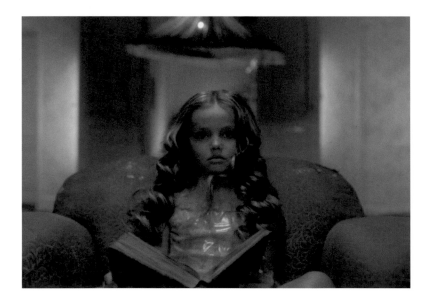

velvet
mediendesign
MEGA

CREATIVE PROCESS

In this redesign of the MEGA channel's identity, each element is part of the whole 'MEGAlicious' redesign package. 'The MEGA world is represented through its MEGAlicious Lady with the MEGA logo, which morphs into five different creatures representing the strands of programming: Love, Joy, Curiosity, Desire and Suspense.'

PRODUCTION PROCESS

The 'creatures' were shot by velvet's creative director and director, Matthias Zentner, in Munich. 'It became a beautiful real-shoot project, which, in the post-production process was combined and mixed

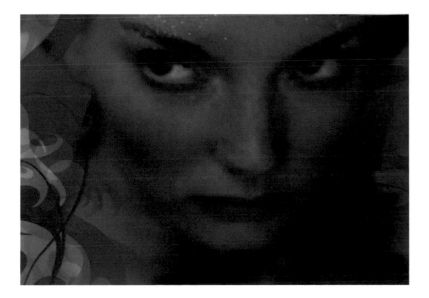

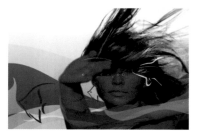

with compositing and 3D animation. As well as the idents, the project contained a new breakbumper, a new promo package and new music!'

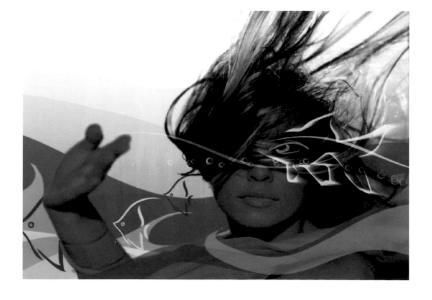

TOOLS

Discreet Flame

CREDITS

Production: velvet mediendesign GmbH
Director: Matthias Zentner
Art director (set): Katja Severin
DOP: Torsten Lippstock
Producer: Anne Tyroller
Styling: Kissi Baumann
Make-up: Christian Hoppe
Post-production:
velvet mediendesign GmbH
Creative director: Matthias Zentner
Lead artist and art director: Martin Kett
Designers: Peter Pedall (layout), Alissa
Burkel (layout, Love and Joy), Achim
John (promotion and teaser), Benjamin
Zurek (layout, Curiosity), Jan Rinkens
(Desire and promotion)
Editors: Anja Rosin, Matthias Zentner
Shake/Combustion: Manuel Voss
Music: Amazonas Studio
Composers: Sven Faller, Gerd Baumann
Sound mix: Michael Gerlach

Waytion
Komeda
'Blossom'

STUDIO PHILOSOPHY

Waytion is a production company that is self-supporting in all stages, from pre- to post-production via directing, photography, illustration, 2D and 3D animation, video effects and editing.

'Waytion's main goals are to produce work that appeals to people beyond its core target audience, to meet the high imaginative standards set by today's creative world and to please a new audience of discerning viewers of TV graphics, commercials and music videos. We are constantly on the look-out for new inspiration, which can come any place, any time.'

CREATIVE PROCESS

Komeda are a band from the north of Sweden, famous for their cool music and stylish approach. For the first single from their fifth album they wanted a director who would do them justice. Finally, after turning down countless other suggestions, they found Waytion (who at that time had still to make a name for themselves) and were impressed by one of the studio's ideas.

Waytion explains: 'After listening to the song for the first time, we all agreed we wanted to make it a story about the band as they travel all around the world in a train full of animals. There was the rhythm and

the beat and the cheerful vocals – "I wanna hear you say we're gonna make a better day" – and at the end of the song they sing "O-oooh, ooooh", which sounds pretty much like a train whistle. We wrote a treatment, which both the record label and the band liked, and based on their feedback we added certain elements like the Northern Lights as a reminder of the band's origins.' The band also asked for specific references to the sources that had inspired them. For example, the film that is being watched in the train could be one by Jean-Luc Godard, and all the other passengers on the train could be their favourite writers.

PRODUCTION PROCESS

After many drafts, sketches, storyboard and animations, the studio had about two weeks to finish it all. 'We ended up with nearly a hundred scenes and, given it was our first music video, we were very pleased with the result. We felt that it was right on the money for this song and this band.'

TOOLS

After Effects, Illustrator, Photoshop Maya, DS, Symphony

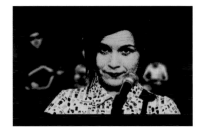

CREDITS

Director, design, animation and video effects: **Waytion**
Universal music A&R: **Benjamin Holmfred**
Photography and post: **Waytion**

Waytion
Nickelodeon Kids Choice Awards

▶

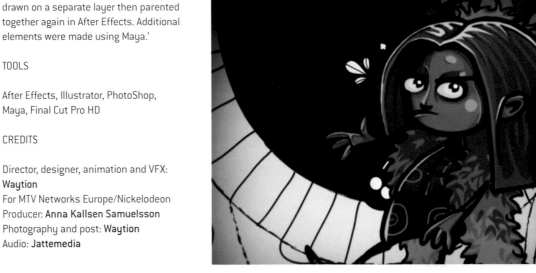

CREATIVE PROCESS

Nickelodeon and MTV Nordic needed some graphics for the first annual Scandinavian version of the successful Nickelodeon Kids' Choice Awards. So Waytion started looking for a suitable style for what, it had already been decided, had to be a cartoonish, animated project. 'The show was broadcast in late October, so we thought we'd use the idea of Halloween in the graphics. Our first idea was loosely based on classic horror themes like Dracula and Frankenstein, with a crazy scientist and his assistant inventing the show and everything in it. The opening would then have a madman in a laboratory, mixing up an evil potion with spiders and crow's feathers, which he makes his assistant drink.'

The problem was that they could not use the idea in case it frightened the younger children in the audience. So the team made a few changes, exchanging the scientist for a director of a group of showbiz people. His assistant would be a tall mystery man, and with him would be Mr Magician, Mr Robot, The Strongman and Miss Diva. The opening sequence would have them performing on stage and introducing the audience to the show.

'It worked out really well. After initially being thought of as a one-off, the format has now been used for three years without any major changes.'

PRODUCTION PROCESS

'Still photos were masked in Photoshop, layered into PSD images, imported into After Effects and spread around in 3D space. The characters were created in Illustrator using a Wacom tablet and the bits that we wanted to animate were drawn on a separate layer then parented together again in After Effects. Additional elements were made using Maya.'

TOOLS

After Effects, Illustrator, PhotoShop, Maya, Final Cut Pro HD

CREDITS

Director, designer, animation and VFX:
Waytion
For MTV Networks Europe/Nickelodeon
Producer: **Anna Kallsen Samuelsson**
Photography and post: **Waytion**
Audio: **Jattemedia**

Why Not Associates
Nike Heroes

\Her"o*ism\ (?; 277), n. [F. h['e]ro["i]sme.]
The qualities characteristic of a hero, as courage, bravery, fortitude, unselfishness, etc.; the display of such qualities.

STUDIO PHILOSOPHY

For nearly two decades Why Not Associates has orchestrated complex campaigns for global brands. At the heart of the studio's diverse body of work is its philosophy of always pushing back the boundaries while also providing the most appropriate solution, one that emerges only after close collaboration with the client.

For the designers of Why Not, 'effective communication contains an element of surprise, and often the best way to solve a problem is to turn it on its head. We're not afraid to run through a dark room with our arms full of lighted fireworks. Fingers grow back, and great work lasts for ever.'

CREATIVE PROCESS

Being true to their creative approach, Why Not created a strong yet subtle identity for Nike with the ambient film *Heroes*, whose theme is heroism in sports.

The studio was commissioned by Nike to create a ten-minute film to be shown in retail stores throughout Europe for six months. The video was to contain no soundtrack and be shown as 'wall-paper' between highlight videos. It would be a constant visual element in the stores and needed to be eye-catching as well as self-explanatory, without the aid of a soundtrack.

Why Not decided to create a film that took the audience on a journey through everyday sports locations where heroic deeds take place. To highlight the beauty and power of these locations they were shown devoid of people. Quotes about heroism were placed in each scene to convey the message. These typographic quotes were created as 3D objects, placed in the environments and revealed through slow camera moves. 'This helped keep the focus on the locations and proved a captivating way of communicating without the use of sound.'

PRODUCTION PROCESS

The team began the project by selecting a number of locations that would cover a wide range of sports and look interesting. Quotes that were relevant to each location were then chosen.

The plan was to place the 3D typography in the live-action scenes by motion tracking on top of the footage as if they were part of the set. The scenes had to be shot empty, using smooth, slow camera moves, and they had to be long enough to contain each quote.

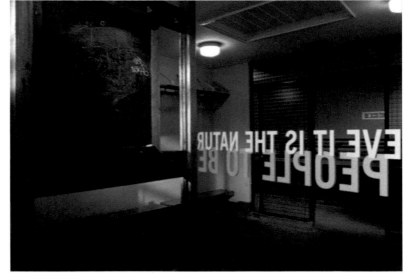

To achieve 'filmic quality', the movie was shot on 16mm film. A dolly and track were used to move the camera in most of the scenes. The footage was edited in-house, and 3D motion tracking was done using Boujou software, which Why Not had never worked with before. It took many weeks of modelling and adding track marks to the live action to get it right.

TOOLS

Illustrator, Photoshop, Maya, Boujou, Cinema 4D, DVD Studio Pro, Final Cut, Flash, Freehand, LightWave

CREDITS

Design, direction, production and animation: **Why Not Associates**
Director of photography:
Alessandra Scherillo
Creative director, Nike: **Bas Van Koll**
Producer, Nike:
Christianne Van der Linden

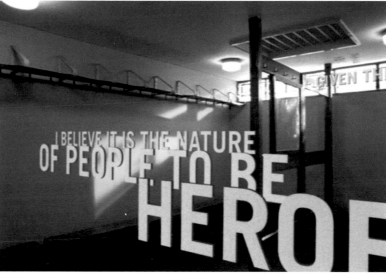

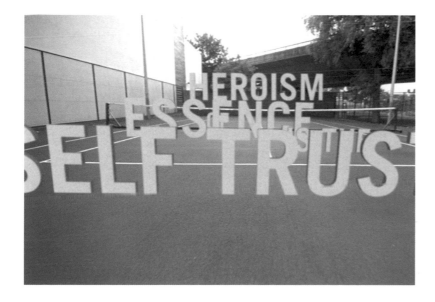

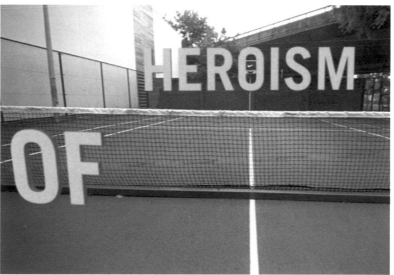

Electrorouge
10 Ans

STUDIO PHILOSOPHY

Electrorouge's design philosophy is to approach a project from the opposite view to that of the client, thereby bringing a fresh outlook to the entire proceeding.

CREATIVE PROCESS

Arte TV channel wanted Electrouge to create 'eye-candy' credits to celebrate its tenth anniversary. 'For this European cultural and niche market channel, the choice was difficult because of the enormous range of topics covered over those ten years, and I rather preferred to express a

"happy smile". I decided to choose the marvellous graphic style in vogue at the time of my own tenth birthday in the early 1980s.'

The studio created a completely vectoral design based on a wonderful childish universe, showing the world being discovered through the cultural medium that this TV channel represents. The process of gradual revelation was the key to the message: Arte is a channel that never fails to arouse the viewer's curiosity.

PRODUCTION PROCESS

The elements were designed with Illustrator. The sharp colours were chosen to convey an upbeat mood. To emphasize the process of revelation the studio directed this vector-based piece with simple motion effects: wipe and slide. 'I also created variations that could be used for an opener, summary, idents and closing credits.'

TOOLS

After Effects, digital editing station

CREDITS

Design, direction and animation:
Electrorouge
Music: **Pascal Holtzer**

WEB

I remember working as the Art Director at Macromedia some time around 1997 when this Product Manager came by my cube and dropped a box of what looked like shareware on my desk. It was Flash.

At the time I had been getting deep into Web design – all HTML, frames, tables and animated gifs. The big trick then was Shockwave and Director. All of the designers on my team would fight over the assignments that involved Shockwave, but after 30 minutes of playing with this new software, Flash, I knew we were in for a change. Flash gave those of us used to the extreme limitations inherent in designing for the Web the chance to spread our wings. There was interactivity, the ability to use any font you wanted and, of course, motion. At first we made everything on the screen move. Graphics flew across the screen for no reason at all. Letters faded up and down, and we spun things with abandon.

So there it was: a revolutionary new technology that Web developers could run with. It was all very liberating, and with it began my journey into motion graphics. I started to pay attention to motion and to justify movement as another powerful way to communicate a message. I learnt that how you move an element is just as important as the element itself, and I became aware of how to lead a viewer's eye, the importance of rhythm and the power of restraint.

The Web is a medium that necessitates change; it always demands technical self-education and creative reinvention, which is what I love about it. It is also a public sketchbook. I know that if I have an idea I can realize it, post it online and potentially have an immediate audience. And that audience will react in some way: maybe subtly, maybe loudly, perhaps not at all, but I'll learn from the reaction, and it may inform my future work.

Those of us designing specifically for the Web all have this feeling that we're somehow responsible for the medium because we are. Our contributions have the potential to shape the medium and to determine its direction.

In this way the Web and by extension Web design and, beyond that, motion design for the Web, function like a series of concentric circles. The Web is a medium that feels both personal and global, a small intimate world and yet one that is completely public, open to everyone. Like the Web itself, those of us involved in the design of this medium all want to keep changing, moving forward, evolving.

Hillman Curtis
hillmancurtis, inc.

hillmancurtis
James Victore

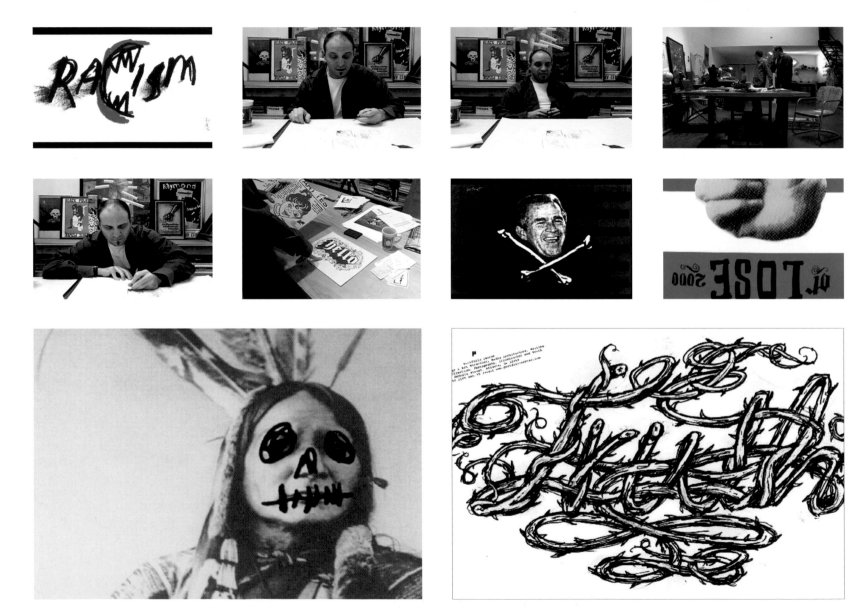

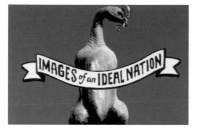

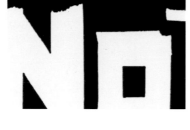

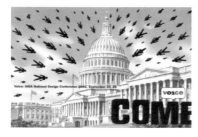

STUDIO PHILOSOPHY

Hillmancurtis, Inc. has been developing work in the online, broadcast and video media since 1998. Creativity, finding the right theme and working with an open mind are factors central to Curtis's artistic approach and to his success. 'We take each job individually, and try to listen for the underlying theme that drives every project. My philosophy revolves around change, which is why being a new media designer suits me so well.'

CREATIVE PROCESS

Curtis produced a series of short online documentaries about designers whose work he admires. The short film about the poster designer James Victore was the third in this ongoing series. Like all of the films, this one offered several unique challenges.

Curtis approaches the production of all of his film shorts in the same manner, with very little pre-planning in the way of location scouting, art direction or discussion with the subject. Instead he simply sets the date and shows up at the designer's studio.

'I quickly scan the studio for the best source of natural light and least amount of room or street noise. I use minimal gear, a very good three-chip DV camera, a tripod and a good shotgun mic, and I do everything myself. The interview process is very personal. I start with a list of questions, but generally we – the subject and I – quickly enter into a conversation. I find that doing the shooting and the interviewing alone allows me to get less practised or guarded answers, as there aren't three or four crew members standing there watching.'

PRODUCTION PROCESS

Curtis begins the production process by capturing his footage onto an external hard drive, which is extracted from his DV camera via a firewire connection. What follows is, for Curtis, the hardest part: reviewing the footage in search of a story.

'Because the story is never immediately apparent, there's no set way I go about finding it. Sometimes I make ten or 15 short edits, then yank the best moments from each into one composite; other times I start with a linear storyline and look for footage that works to tell that story. With the Victore piece I tried to make a linear rough cut from the start, but it was awful. I was on the verge of giving up the project when I took a break one night, drank a generous glass of red wine and listened to music. I was playing my iPod on "shuffle" and came upon a song by the Scottish band Mogwai. As soon as I heard it, I knew exactly what to do. I would use the Mogwai song as my musical support and build a sort of music video revolving around the beauty and power of Victore's art, interspersing the montages of his work with only the best footage and choicest quotes from Victore himself. When you are ready to give up, look

around and find the inspiration that will help you revitalize your work.'

TOOLS

After Effects, Final Cut Pro HD

CREDITS

Producer, director and editor:
Hillman Curtis

uncooked and Jeremy Miller Design Studio

uncookedland

Uncooked say they first met Jeremy Miller of Jeremy Miller Design Studio in the Self-Help section of Barnes & Noble when they simultaneously reached for the book *Cooking Without Hands*.

'Immediately we knew this shared interest for people without hands was more than a coincidence. We agreed it was in our best interests to get to know one another over a delicious meal of salmon steaks. Just as we suspected, by the end of the day we discovered that not only do we all not speak Finnish or have an STD that we know of, but we all have a dream to create a website unlike any other website in the universe. Two months later uncookedland was hatched.

'If in your heart you know that what you've created is great, trust it. It is not wise to ask the outside world to approve of something they could never understand. In fact, their critique will only misdirect your vision and make you doubt yourself. And once you enter into self-doubt, you might as well call it a day.'

CREATIVE PROCESS

At first there was a lot of back-and-forth thinking. 'Sometimes we would all sit in a room and think about the website, and then we'd get hungry and leave. Finally we realized that if we brought lunch into the room that we were thinking in, maybe we all wouldn't leave so abruptly. By the end of the week we had a very loose idea of how we wanted uncooked to be seen on the web. All we knew was that we wanted to create a land where a bird with glasses did something interesting. Jeremy, being the child genius that he is, could see this land and near-sighted bird in greater detail. He came back to us with some amazing ideas that totally blew us away.'

PRODUCTION PROCESS

'Our production stages were probably
very different from other people's.
From the beginning of production to
the end it's probably safe to say that
not one other person out there had
the exact same experience as us.'

TOOLS

Illustrator, Flash

CREDITS

Writing, illustration and concept:
Natalie Carbone and Armand Prisco
Animation and website: **Jeremy Miller**

NOTES

Foreword

1 CS Lewis, *Surprised by Joy: The Shape of my Early Life*, (Florida: Harvest Books, 1966.)

2 Markos, Louis. *Life and Writings of C. S. Lewis*. (Audio Lecture Series, Virginia: The Teaching Company, www.teach12.com, 2000.)

3 Wordsworth, William, *The Prelude*. (New York: Norton, 1979.)

4 Markos, Louis, *op cit*.

Introduction

1 Negroponte, Nicholas *Being Digital* (First Vintage Books, 1995)

2 *Webster's New World Dictionary*, 3rd College Edition (New York: Simon & Schuster, 1997)

3 Greene, Brian *The Fabric of the Cosmos* (New York: Borzoi/Knopf, 2004)

GLOSSARY

3D/CG 3 dimensional computer generated graphics

Analog Video or audio data recorded using an electronic signal that varies continuously

Animatics A rough moving image sequence usually consisting of sketches and photographs, used by the director to represent and test early ideas

Assets Source material used in a motion graphic composition, usually comprising still images, video and audio

Atmospheric particle Graphic element used to simulate atmospheric effects

Back-plates Background elements over which foreground elements, usually live action footage, can then be composited

Back-story History or story behind the main narrative of a motion graphic sequence

Blue screen A blue (or green) background placed behind objects or actors in a scene. In post production the background is easily removed therefore isolating the object

Breakbumper Brief animation of a logo and/or graphics before or after a programme goes to an advert break

Bumper Animation or video piece used to provide a transition between two other pieces of content

Camera mapping Projection of an 2D image through a camera, typically a background image onto 3D geometry

Camera pass Reproducible camera movement used to obtain shots with different lighting and effects but with identical camera movement

Caustic effects Use of simulating light photons in a 3D scene, to create realistic lighting effects

Cell animation Early animation technique using images on celluloid, overlaid on static backgrounds

Centre cut-out An option to display a 16:9 ratio widescreen image on a non-widescreen 4:3 ratio television, whereby the wider widescreen image is displayed centrally fullscreen therefore cropping the edges off the wider 16:9 ratio image

Centre extraction See *centre cut-out*

CG particles Computer generated particles

Character design Preliminary sketches and drawings of characters

Character generator Technology used to produce dynamically created text

Colorama Black, white or coloured background paper, onto which lighting effects or images are projected to provide a background for foreground elements

Colour correction The process of adjusting colour levels throughout a composited scene

Colour treatment See *colour correction*

Compositing The process of combining different pieces of video and images into one single moving image sequence

Conform The process of editing a motion sequence to fit its sound track length

Cyc Cyclorama, a coloured gradually curved background surrounding foreground elements, usually coloured green or blue

Digital mask Mask used in compositing software to hide and reveal elements

Digital tablet Device from which hand-drawn movement and position are collected

Down-conversion Conversion of High Definition content down to Standard Definition

DV Digital video

Encoding Optimizing video and audio for transmission or storage

End-board Closing sequence or graphic of a television programme

Environment A 2D or 3D space that contains scenes and objects

Fall-off materials Material option setting in 3D software to simulate realistic reflection angles on shiny objects

Grading The process of establishing and modifying colour values throughout a film or sequence to achieve a consistent desired look and feel

Graphic frame sequence Sequence of individual images where each image represents one frame

Green screen See *blue screen*

HD High definition, higher than standard resolution, exists in two formats 1280 x 720 pixels or 1920 x 1080 pixels

Ident Brand identity of a television channel, usually animated or accompanied by music

In post Refers to work in post-production

Interactive lighting Set lighting that can be dynamically switched between different lighting arrangements

Key See *Matte*

Keystoning Distortion of an object within an image or film when the camera is not shot at the object at a perpendicular 90° angle

Layers Used in design software to arrange content on top of one other

Lensing Process of establishing camera lens parameters

Letterbox Black bars that appear above and below video, when widescreen footage is shown on a non-wide screen 4:3 ratio television

Light wrap Compositing software effect to simulate how background light glows around foreground objects

Live action Footage captured by a Film or DV camera

Locking See picture-lock

Matte An image placed behind or before content to provide a background or foreground. Mattes are also used to isolate content during compositing

Modelling The process of creating a 3D object

Motion curve Curve on a graph depicting the velocity of an object over time

Motion tracking Utility used in compositing software to track the motion of an identified element within a motion sequence, and provide horizontal and vertical coordinates for each frame for that element

NTSC Television format used in North America, established by the National Television Standards Committee

Opener An opening motion sequence with a narrative that precedes a title sequence

Parallax The effect created when multiple background and foreground layers are animated at different speeds to give the illusion of depth

Particle generation Computer generated particle sized graphics, produced to simulate natural phenomenon such as fire

Picture-lock When the editing process of a motion image sequence has been completed

Plug-in Additional piece of software that works with another program to provide additional functionality

Post-edit Editing process of post-production

Post-processing Process that manipulates a portion of footage such as applying an effect

Post-production Processes that take place after production, including digital manipulation, editing, and sound dubbing etc.

Pre-visualization Mockup animation designed to test ideas before production

PSD layouts Photoshop Document containing graphics and other imagery

Render Process of design and animation software to export the final moving image sequence or an individual image

Rotoscoping Technique used to trace around an element in a moving image frame by frame

Shooting board A detailed version of a storyboard showing what will need to be captured by the camera shot per shot

Shot particles Real particles captured on a film or a DV camera

Slide Transition from one sequence to another, where the replacing scene pushes the current scene off screen, either from top to bottom, left to right or vice versa

Slide-to-video conversion Process of converting photographic slides to video

Standard definition The regular resolution of television broadcasts, 768 x 576 pixels for PAL and 720 x 480 pixels for NTSC

Sting A very short motion graphic sequence accompanied by sound

Stop-motion animation Animation sequence created by recording static elements one frame at a time, the elements slightly repositioned in each frame giving the illusion of motion

Storyboard A series of sketches outlining the sequence of events of a motion graphics sequence

Style frame Static design of a single frame, from which motion graphics are designed

Teaser Short edited sequence aimed to promote and entice an audience to watch a film or television programme

Textures Images of real world surfaces mapped onto 3D geometry or 2D areas

Title card Early title sequences used printed text, which were then edited into the title sequence, title card is still used to refer to each individual title shot

Toon shading Computer graphics rendered to appear as a hand-drawn cartoon

Tracking See *motion tracking*

Track marks Markers placed within a live action scene, and later used in post-production to capture data on camera movement

Transition Method of moving from one sequence to another, usually utilizing some form of effect

Typographic card See *title card*

Vector animation Animation of 2D computer defined graphical shapes

VFX Visual effects

Video mixing Device used to combine two or more video sources and output them to a single video source

Vignette A short stand alone scene

Wipe A transition from one sequence to another where the replacing sequence is revealed gradually by animating a mask across the screen from left to right or top to bottom. Eventually as the mask size expands to the entire screen size the original image is completely hidden.

World Digitally created 3D environment

BIOGRAPHIES AND WEBSITES

Addikt Design Movement

Addikt Design Movement, based in Amsterdam, was set up in 2004 by Sander Lipmann, Koen van Ovoorde and Barry Schwarz. All three share a background in graphic design and in 3D and broadcast design.

Addikt specializes in motion graphics and 3D animation, in particular in the area of brand design. Most of the group's clients are advertising agencies or similar commercial enterprises. Rather than just selling a product, Addikt focuses on ways to give new emotional resonances to a brand or to reinforce those values already associated with it. While never losing sight of the brand's core values, the group accentuates aspects that are relevant for the target audience, so that the overall design, mood and style of animation are a reflection of the brand itself: 'We create a style that fits the project.' Clients include Canal+, Vodafone and Pepsi.

www.addikt.nl

BL:ND

BL:ND is a full-service design, production and post-production company whose work includes editorial and live-action directing for commercials, broadcast television and film. Since it was established in 1995 it has garnered numerous industry accolades and awards and assembled a strong list of national and international clients.

Located in Santa Monica, BL:ND resides in the heart of the post-production community. As a boutique creative shop, it employs a diverse team of award-winning designers, animators, editors and film-makers.

www.blind.com

Buraco de Bala

Buraco de Bala's first commission was to create the opening sequence for a music programme produced by the Communications Department at a local university. Their first crew comprised students from another university, the Universidade de Brasília, and most of the team were design and art majors, so the members' academic lives were important in the foundation of the company. Many of their clients and colleagues date back to this time.

The company's breakthrough came when they were invited to originate and oversee the technical development of a short film for Limpeza S.A. They showed a demo reel to MTV and to the designer Nando Costa, both of whom subsequently commissioned animation projects from them.

www.buracodebala.com

DIGITALKITCHEN

DIGITALKITCHEN was founded in 1995 by Paul Matthaeus as the digital studio for his independent advertising agency in Seattle. The DIGITALKITCHEN ethos has always been to cultivate and promote experimentation and creativity in full-motion film and electronic media, leveraged with an agency-based faculty for strategic brand-building.

Today the work of DIGITALKITCHEN has been seen in over 100 countries, has garnered awards in every major industry forum, has been featured in general and trade publications including *The New York Times*, *Wall Street Journal*, *Entertainment Weekly* and *AdWeek*, and is part of the permanent collection of the Museum of Modern Art, New York. *Time* magazine hailed DK's work for the series *Six Feet Under* as 'TV's most gorgeous opening credits.' DIGITALKITCHEN has twice been voted best by the Association of Independent Commercial Producers (AICP). Since 2002 DK has attracted numerous Emmy nominations.

www.d-kitchen.com

Electrorouge

Electrorouge (aka French designer Sam Burkardt) is a one-man studio pursuing a career as a 'media nomad', journeying through various graphic universes and experimenting with a range of techniques. After working as a graffiti artist for five years, using spraycans, since 1995 Burkardt has been developing his own eclectic and innovative approach to design, embracing a variety of styles in order to tell stories through moving or interactive images. Electrorouge clients include Arte, TF1, Canal+, Nintendo, La Villette, Viva+, The Disney Channel and Samsung.

www.electrorouge.com

Feedbuck Galore

Feedbuck Galore was set up with a single goal – awe-inspiring art. It was founded in New York City in 1993 by Missy Galore (aka Melissa Kaminsky) and Jon Buckley. In 2003 Sabrina Roulet joined the team and the Feedbuck Galore Paris division was created.

Feedbuck is one of the world's first VJ companies. They use cutting-edge technology while respecting the medium's roots, bringing video mixing out of the studio, and creating performance works from a range of media. Their live video mixes, projection environments and video sculptures have been seen in over 2000 venues, from night-clubs to the United Nations, the Woodstock Festival to the Warhol Museum. Beta testers for new machines, entertainers at museums, party fixtures on different scenes – their mission is to promote art in action across the many facets of 21st-century culture.

www.feedbuckgalore.com

Foreign Office

Foreign Office is a London-based studio of directors, animators and designers, specializing in motion graphics for film and TV. Its founders, Sonia Ortiz Alcón, Matteo Manzini and Fredrik Nordbeck, provide a mixture of Latin flair and Scandinavian precision at the creative heart of a studio that pays little heed to preconceived rules about design.

The foundations for the partnership were laid at Central St. Martins College of Art & Design in London, where the three met as undergraduates. Since its inception in 1999 Foreign Office has evolved from being a purely creative engine immersed in web and print for clients as diverse as Philippe Starck and playstation.com to producing music videos for Warner and Sony. Recent commissions have included animated identities for various MTV programmes through to a five-minute corporate piece to launch the latest Nokia mobile handsets. Further evidence of the company's versatility is provided by the traditionally animated three-minute opening credit sequence for the film *Mrs Henderson Presents*.

www.foreignoffice.com

hillmancurtis, inc. 148–149
Hillman Curtis is a designer and film-maker, whose company, hillmancurtis, inc., has designed websites for Yahoo, Adobe, Aquent, the American Institute of Graphic Design and Fox Searchlight, among others. His film work includes the documentary 'Artist Series', as well as two short narrative films. His commercial film work includes short films for *Rolling Stone*, Adobe and BMW.

Curtis's three books on design and film have sold close to 200,000 copies and have been translated into fourteen languages. He splits his time between San Francisco and New York City.

www.hillmancurtis.com

Manabu Inada 94–97
Manabu Inada began his career as a senior graphic designer at MTV. In 1998 he won an AIGA Graphic Design Award for his work at MTV, where he subsequently became an executive producer. As an artist, Inada's short film *Drifting Resident* was exhibited at MOMA PS-1, New York. In 2001 he was selected as one of the 'Top 40 Designers' in the book *Extreme Design*. Recent projects undertaken by his company, Inada Studio Inc., include an advertising campaign in Japan for the James Bond film *Die Another Day*.

www.inadastudio.com

mateuniverse 84–89
Based in Berlin, mateuniverse represents the personal and professional work of communication designer Jan Mathias Steinforth. Born in Hanover, Germany in 1977, Steinforth has professional experience in the areas of multimedia and graphic design and has worked for various media companies, both full-time and freelance. He started working in web design in the late 1990s and now specializes in motion graphics.

Steinforth has been touring Europe for several years. His motion graphics have been screened at various art and electronica festivals and on TV.

Steinforth's visual style has been described as 'deconstructionist abstract', with a particular facility for impressive 3D effects, and for space and depth. His approach to his art is rooted in having an immediate visual response to any given auditory and emotional situation.

www.mateuniverse.de

Mathematics 60–63
Mathematics is a design and film studio based in Sydney, Australia, under the directorship of Josh Logue. Working mainly with the music industry, since 2003 the company has been directing and producing both live-action and animated music videos. Alongside its video work, Mathematics also creates websites and designs CD artwork for both Australian and international artists.

www.xy-1.com

National Television 120–129
National Television is based in Los Angeles and specializes in the field of motion graphics and animation. It was set up by four veteran artists and producers, all with extensive experience working for some of the top design firms in LA. Chris Dooley, Brian Won and Brumby Boylston are the co-creative directors, and Steiner Kierce is head of production. National Television's current clients include Mother London, Wieden + Kennedy, Ground Zero, Nike, MTV2, Nick @ Nite, G4 Television, Nickelodeon, CMT and Comedy Central.

www.natl.tv

Brody Neuenschwander (featured on the DVD only)
Brody Neuenschwander is a calligrapher and text artist whose work explores the boundaries between text and image. In many of his collages and painted works image and text merge, implying that the two may be read according to the same set of rules. Other works contradict this idea, suggesting that there may be no way of reconciling these two different ways of reading the world.

Neuenschwander sees his work as being related to Conceptual art. In one work the image of Joseph Beuys is followed by a dialogue with the German artist, writer and teacher. In another, the word 'Orientalism' undermines the idea that calligraphy must always be associated with the East.

Neuenschwander has collaborated with the film director Peter Greenaway on a number of films, operas and exhibitions, including the cult film *The Pillow Book*. These projects have brought him recognition in the fine art world as well as a dedicated following among graphic designers, typographers and graffiti artists.

www.bnart.be

Joakim Oscarsson 58–59
Joakim Oscarsson started his professional career as a graphic designer at Razorfish in 1999 before moving to Moonwalk as art director. He now works as a freelance designer while also studying industrial design at Konstfack University College of Arts, Crafts and Design in Stockholm, Sweden.

www.joakimoscarsson.com

PMcD Design 114–119
PMcD Design is a New York-based firm that specializes in broadcast design. Founded by Patrick McDonough in 1993 it provides all phases of design development, graphic production, film direction, music/sound design and corporate image creation. The studio likes to work on an intimate scale, cultivating a personal vision for each design task, inviting innovation and participation in the development of a shared visual concept for each project.

PMcD describes its approach as being 'to visually translate ideas based on strong design', to create 'a voice, an image, a structure, consistently focused, to enhance and support the brand concept' and to 'set to an overall tone and mood, a direction for the future'.

www.pmcddesign.com

Prologue Films 26–31
Prologue Films is a Malibu-based company that specializes in film and broadcast design. Formed in 2003 by Kyle Cooper, it has grown into a diverse team of 20 comprising designers, animators, editors, directors and producers. With this expanding group Cooper continues to build on a body of work that includes more than 150 film title sequences, numerous advertising campaigns and various projects in branding (broadcast, interactive, environmental), entertainment marketing and video game design.

Cooper earned an MFA in graphic design from the Yale University School of Art and holds the honorary title of Royal Designer for Industry from the Royal Society of Arts in London.

www.prologuefilms.com

PSYOP 98–101
PSYOP disseminates imagery, ideas and advertising from its headquarters in New York. Founded in 2000 by Marie Hyon, Kylie Matulick, Eben Mears, Todd Mueller and Marco Spier, the organization focuses on collaborative design with a distinct conceptual edge.

PSYOP is a term for government or military operations designed to modify the opinions, emotions, attitudes or behaviour of a target audience, thereby convincing them to cease resistance or alter their behaviour in a manner favourable to friendly forces. The company chose the name to express its belief that the media is as powerful in modern society as the military.

PSYOP is a fully independent creative design/production squad dedicated to the cultivation of mind over pixel who blend the disciplines of design, animation and live-action directing.

www.psyop.tv

Renascent 102–103
Based in Amsterdam, Renascent is the brainchild of the Dutch designer/director Joost Korngold, who is active in both motion graphics and static imagery for various media. The company started out as a creative offshoot of Korngold's full-time job as a New Media designer. He set Renascent up as a one-man company in November 2002.

www.renascent.nl

Stylorouge 104–109
Stylorouge is a ten-strong creative consultancy founded in London in 1981 by creative director Rob O'Connor. Work for musical artists such as Blur, Simple Minds and George Michael have earned them a worldwide reputation, alongside their designs for the Rolling Stones, David Bowie and Paul McCartney. Other work includes cinema – film credits include *Trainspotting* – fashion, retail, publishing, corporate identity and exhibition projects. They have also produced promos and concerts for Madonna, The Corrs, Crowded House and David Gilmour, and have worked on documentaries about Feeder, Enya and Kula Shaker, while their TV commercials include adverts for Universal, BMG and Sony. Their websites have been short-listed for the BT Awards, and a book showcasing their work, *Delicious*, was published in 2001.

www.stylorouge.co.uk

Tommypost 82–83
Tommy Korad (whose digital nickname is Tommypost) has more than 15 years of graphic design experience, and has spent over a decade working in motion graphics. He ran a successful design firm in his native Thailand, where he won the Bangkok Art Director Award. In 1997 he moved to New York, where his achievements have brought him clients spanning the Fortune 500 list. Tommy is a futurist, keeping pace with the latest developments in every facet of design and technology.

www.tommypost.com

Troika Design Group 46–51
Troika Design Group is an award-winning design company known for producing trend-setting visual brand identities. Based in Hollywood, it comprises a unique amalgam of skills, with a team of more than 20 designers, producers, animators, editors and conceptual thinkers who specialize in network branding, promotional and advertising campaigns, and show packaging. Founded in 2001 by Dan Pappalardo, Mark Bohman and Chuck Carey, Troika is one of the major providers of strategic design and creative production for television. The company's approach to design is clever, thoughtful and focused, delivering stand-out concepts while remaining faithful to the client's brand ideals. Troika has worked closely with top television and cable networks including FOX, ESPN, HGTV, E! Entertainment, Food Network, ABC, UPN, Comedy Central, Fine Living, VH1, TV Guide Channel and Great American Country.

www.troika.tv

Trollbäck + Company 22–25
Trollbäck + Company is a creative studio committed to generating innovative visual and branding solutions. Strongly

rooted in the European design sensibility and tradition, the young multidisciplinary company works across a variety of media, from film titles and trailers to TV commercials, environmental and architectural installations, network branding, outdoor advertising, magazine and book design. Trollbäck + Company has a presence on both the west and east coasts of the USA, with design and production studios on Fifth Avenue, New York and Venice Beach, California.

www.trollback.com

Uncooked and Jeremy Miller 150–151
Uncooked, Inc. was co-founded by Natalie Carbone and Armand Prisco. The company, based in New York City, was launched in 2004 as a greetings card company and production company specializing in short-form animation. Jeremy Miller, also based in New York City, works in web, publication and packaging design. He started his own firm, Jeremy Miller Design Studio, in 2001.

www.uncookedland.com
www.jmillerstudio.com

V12 110–113
Based in Universal City, California, V12 is a BRANDESIGNIMATION™ company that specializes in television commercials, network on-air packages, main titles and promos. It was founded in 1998 by the design director David James Hwang, a former co-founder of Two Headed Monster, with the design director David Sparrgrove, producer Jennifer Lucero and editor Alex Recsan. V12 are practitioners of the 'Engage and Communicate' method, by which ideas and messages are conveyed through an appropriately seductive and beautifully executed form. This approach is apparent in their award-winning works over the years.

www.v12.tv

velvet mediendesign 130–137
Velvet mediendesign is a creative design agency and film production company based in Munich. It was founded in 1995 by Matthias Zentner and Andrea Bednarz, and has won numerous international awards.

The agency's main areas of activity are represented by the departments into which the company is divided. Velvet Design specializes in broadcast design for on-air and off-air TV channels and networks, as well as website design and image campaigns, film titles, corporate design-in-motion and production design from animation to live action. Velvet Art produces installations and video art for fairs, trade shows, events, showrooms, museums and public buildings (art in architecture) and communication strategies for big screens and foyers. Velvet Film creates adverts for cinema and TV, corporate image films, image campaigns and short films. Velvet Corporate produces complete corporate design and branding solutions: logo design, logo animations, stationery, design creations for special events, websites and merchandizing.

www.velvet.de

Waytion 138–140
Jonathan Karlsson and Tommy Håkanssan met at school in the mid-1990s. They often talked about working together in the future and eventually decided to do so when they met again at the 3D and post-production school in Stockholm. They were joined by an old friend, Erik Gullstrand, a skilled production manager/producer, who at the time was project manager at an advertising agency. Their work spans everything from illustration for daily newspapers and print ads to animation and directing of commercials and music videos.

www.waytion.com

Why Not Associates 141–143
Why Not Associates is a British graphic design company with clients, both large and small, in business, government and the public sector in a number of countries. For nearly two decades the team has been working in a range of media and on many different types of project, including corporate identity, digital design, motion graphics, television commercial direction, environmental design, publishing and public art.

With this breadth of experience they have been able to orchestrate complex campaigns for global brands such as Nike, First Direct, Virgin and the BBC, but they also enjoy working on smaller locally based commissions such as publicity material and public art installations for regional government.

www.whynotassociates.com

yU+co. 38–43
Garson Yu founded yU+co. in 1998 to serve as a platform for an innovative, concept-driven approach to graphic design, offering clients the opportunity to capitalize on the growing convergence of media and technology. He gives interactive solutions to the ever-evolving advertising, branding and creative needs of his clients. His credits include main title sequences for such films as *Stealth*, *Herbie: Fully Loaded*, *Taking Lives*, *The Hulk*, *Matchstick Men*, *The Italian Job*, *Mission Impossible 2* and *Lost Souls*. He has also designed many corporate IDs and logos, including the Dolby Digital surround sound theatrical logo and the Sony WEGA Engine logo. At yU + co. Yu has conceptualized, designed and produced many high-profile commercial projects for Circuit City, AOL, American Express, Nokia, Verizon, Coca-Cola, Motorola, Boeing and Toyota. Network branding projects include graphics for HBO, CNN, Cartoon Network, ESPN, Fox Sports and TNT.

www.yuco.com

ACKNOWLEDGMENTS

Dedication
This book is dedicated to the 50th anniversary of motion design and also to the visions of Saul Bass.

Authors' Acknowledgments
The authors would like to thank Jo Lightfoot, Emily Asquith, Andy Prince, Laurence King, and all the people involved at Laurence King Publishing. Thanks to all the contributors to our book, especially Kyle Cooper, Dan Pappalardo (Troika), Garson Yu, and Hillman Curtis for their invaluable writings. Thanks also to Julie Barker for providing her editorial expertise. Extra thanks to our special friends who gave us inspiration: Ned Davis and Karen Karibian.

Extra special thanks to Tina Havemeyer, our research editor, and Eileen Stevens, our audio voiceovers producer, Jeffery Woodman, the primary voice on the DVD, David Weissman, our audio engineer, Walter Koehli, our technical adviser on the DVD production, and Matt Verzola and Jordan Wotkowski, along with Full House Productions, New York City, and Jeremy Miller who helped us complete our vision.

Picture Credits
The authors and publisher would like to thank all the studios who have given their permission to print material in this book and on the accompanying DVD. Every effort has been made to acknowledge the owners of copyright material. In the event that any changes should be made to the acknowledgments, the owners should contact the publisher who will make corrections to any future editions.

Numbers refer to pages
22–23 Mirabai Films
24–25 Universal Pictures, Dreamworks, Imagine Entertainment, a Ron Howard Production
26–27 Columbia Pictures, A Marvel Enterprises/Laura Ziskin Production
28–29 Warner Bros. Pictures
30–31 Toho Company Ltd/Shogo Tomiyama
32–33 HBO/Actual SIze Films/Greenblatt Janollari
34–35 HBO/FX/Shepherd Robin Co.
36–37 HBO/ABC/Sony Entertainment/Stephen King/ Mark Carliner
38–39 Warner Brother Pictures, in association with Village Roadshow Pictures, a Mark Canton Production
40–41 Universal Pictures
42–43 An Original Film, Phoenix Pictures, Laura Ziskin

46–47 ABC
48–49 ESPN Network
50–51 TV Land Network
52–53 Addikt self promo
54–55 Casema Kabelbreed Internet
56–57 Addikt self promo
58–59 Family Affair
60–61 Liberation Music
62–63 Warner Music, Australia
64–65 VH1 Network
66–67 Fuse TV
68–69 Elektra
70–71 MTV Brazil
72–73 Volkswagen
74–76 Levi Strauss
77–81 MTV
82–83 DiscoverCard/Shearson-Liemann
84–87 Jan Mathias Steinforth (mateuniverse)/Funkstörung
88–89 Jan Mathias Steinforth (mateuniverse)
90–93 Feedbuck Galore
94–95 Manabu Inada
96–97 Manabu Inada
98–99 Nike Corporation
100–101 Interscape Records/A&M Records
102–103 OFFF 2005
104–105 Chris Coco and Sacha Puttnam
106–108 Stylorouge self promo
109 Zena Holloway
110–111 ESPN Network
112–113 NBA/ABC
114–115 Muhammad Ali Centre
116–117 Encore Television Network
118–119 Starz Television Network
120–123 Virgin Music
124–126 The *Observer* Magazine
127–129 Nike Corporation
130–131 E-City Network, Japan
132–134 Showtime Television Network
135–137 Mega Channel Network, Germany
138–139 Sonet/Universal
140 Nickelodeon Network/MTV
141–143 Nike image design, Amsterdam
144–145 ARTE GEIE
148–149 Hillman Curtis/James Victore
150–151 Uncooked self promo